IMAGES
of America

PITTSBURGH'S
SOUTH SIDE

IMAGES
of America

PITTSBURGH'S SOUTH SIDE

Stuart P. Boehmig

ARCADIA

Published by Arcadia Publishing
Charleston SC, Chicago IL, Portsmouth NH, San Francisco CA

Printed in the United States of America

Library of Congress Catalog Card Number: 2005932359

For all general information contact Arcadia Publishing at:
Telephone 843-853-2070
Fax 843-853-0044
E-mail sales@arcadiapublishing.com
For customer service and orders:
Toll-Free 1-888-313-2665

Visit us on the Internet at http://www.arcadiapublishing.com

"Pittsburgh . . . is without exception the blackest place I ever saw. . . .
As regards scenery, it is beautifully situated, being just at the junction of
the two rivers, Monongahela and Allegheny. . . . Nothing can be more
picturesque than the site."
–Anthony Trollope in the 1860s.

To my parents who taught me to love this town and the people in it.

CONTENTS

ACKNOWLEDGMENTS

I set out to make a compilation of the images of the South Side so they could be made readily available to the general public. I am grateful to those who preserve and look after these archives, Gil Pietrzak of the Carnegie Library of Pittsburgh, Louise Sturgess of the Pittsburgh History and Landmarks Foundation, Miriam Meislik of the Archive Service Center of the University of Pittsburgh, Brooke Sansosti of the Carnegie Museum of Art, and Lauren Zablelsky of the Historical Society of Western Pennsylvania, all of whom kindly helped me sort through the images. The images in this volume are drawn from the collections of (t=top of page, b=bottom of page) the Carnegie Library of Pittsburgh: pages 10, 11, 12, 13, 14, 16, 17, 18, 19, 20, 21, 22, 24, 26, 27, 30, 31, 33t, 38, 42, 43, 44, 45, 47t, 49, 50t, 51t, 54, 55, 58b, 59, 67t, 68b, 69b, 72t, 74, 75, 76, 79, 81t, 83, 84, 87t, 93b, 94b, 97b, 98b, 99, 101, 103, 104, 105, 108, 109, 110b, 112, 115, 117t, 118b, 119, 120, 121, 122, 123, 124, 125, and 126; Archives Service Center, University of Pittsburgh: 32, 43b, 46, 47b, 50b, 51b, 52, 56, 57, 58t, 59b, 60, 61, 62, 63, 64, 65t, 66, 67b, 68t, 70, 71b, 77, 87b, 89, 90, 92b, 93t, 110t, 111, 114, 117b, 118t, and 128; Historical Society of Western Pennsylvania: 23, 28, 29, 33b, 34, 35, 36, 37, 48, 78, 80, 81b, 82, 86, 91t, 92t, 96, 97t, 98t, 100, 102, 113, and 116; Pittsburgh History and Landmarks Foundation: 71t, 72b, and 127; Carnegie Museum of Art: 39, 40, 69t, 91b, 94t, and 106. I would also like to acknowledge the South Side Local Development Company for its commitment to maintain the heritage of the South Side.

INTRODUCTION

If one were to make the journey through the wilderness of the Allegheny Mountains to visit Maj. Gen. John Ormsby at Fort Pitt in 1763, they would notice the confluence of two rivers, the Allegheny and the Monongahela, which converge to form the mighty Ohio. Starting on the Ohio, one could travel all the way to New Orleans and the Gulf of Mexico without ever having to paddle upstream.

One would also notice the dominant topography of the area. There were hills; lots of steep, unusable hills, all carved by rivers and glaciers thousands of years ago. There was one exception. To the south, along the banks of the Monongahela, there were nearly 3,000 acres of flat bottom land. This was the only level ground surrounding the rivers. Less than 100 years later, this wilderness would be called the workplace of America, the heart of the great Industrial Revolution.

The land, from the present day Smithfield Street Bridge to Beck's Run Road, was granted to Maj. Gen. John Ormsby by King George III in 1763 for his service in capturing Fort Duquesne during the French and Indian War. He named the land Homestead Farms. Ormsby, an Irishman educated at Trinity College in Dublin, came to America in 1752 to seek his fortune. He first came to Pittsburgh with Gen. John Forbes in 1758 to fight in the French and Indian War. In 1764, the 44-year-old Ormsby married 17-year-old Jane McAllister in a ceremony at Fort Pitt. They kept a store, tavern, and ferry in Pittsburgh along the Monongahela River, near the site of what is today the concrete pads of the Monongahela Wharf parking lot.

As far as is known, he was the first settler in this area with a higher education, and he has been called the first citizen of Pittsburgh. In this frontier community, he was described by Barbara Negley as "a fine looking man of aristocratic and military bearing, a gentleman of the old school, noted for his immaculate breast and sleeve ruffles, the brightness of his shoes and knee buckles."

In 1805, Ormsby died, and his son-in-law Dr. Nathaniel Bedford, who married Ormsby's daughter Jane, inherited the 3,000 acres of bottom land. In 1811, he laid out a town and named it Birmingham after his hometown in England. It extended from present day Sixth Street to Seventeenth Street. By 1816, Birmingham had over 50 houses (which were mostly made of brick), one glass factory, a sawmill, and a coffee factory. It was eventually connected to Pittsburgh in 1818 by a covered bridge built at the site of the present day Smithfield Street Bridge. It cost 2¢ to walk across the bridge. Later expansion extended East Birmingham, then known as Sidneyville, from Seventeenth Street to Twenty-seventh Street, and Ormsby, extending from Twenty-seventh Street to Beck's Run Road.

One of Maj. Gen. Ormsby's children was named Oliver. Oliver had seven daughters and one son. Five of the daughters and his only son, Oliver Jr., lived in estates, connected side by side in East Birmingham, between what is now Twenty-first and Twenty-fifth Streets. Each daughter had her own house and gardens branching down to the river.

Josephine married Edward Yard, a commandant in the U.S. Navy, and lived in a house with a pillared porch, long windows, and a terraced garden overlooking the river. It was located near present day Twenty-first Street. Oliveretta, the youngest daughter, and her husband Lt. Col. Clifton Wharton, also lived there. Sidney married John Harding Page and lived at the Dingle. Sarah married Maj. Asher Phillips and lived at the Orchard, known for its rose gardens. Mary married Lt. Elias Phillips, a West Point graduate and brother of Asher Phillips, and lived in the White House. The girls' only brother, Oliver Jr., lived on the hillside above his sisters in a place called Ormsby Manor, located at Twenty-fifth and Josephine Streets. The entrance road is now called Kosciusko Way. The manor was a country gentleman's estate with forests, meadows, and a small private racetrack.

Today, all that remains of the manor is single brick dwelling, which was part of the original mansion. The fireplaces have been boarded up and the large rooms have been cut into quarters by partitions. The racetrack is now a gravel parking lot. Oliver Jr. studied medicine at the University of Pennsylvania and died in 1832. The borough of Mount Oliver was named after him. Many of the streets in the South Side are named after the Ormsby family.

Originally, the growth of the South Side was due to the development of the glass factories. Later, it was the steel industry which forged the community's reputation as the steel capital of the world. The people who worked in the mills and factories lived in row houses on the "flats" and, if you could handle the climb, the "slopes," which were accessible by hundreds of steps carved into the side of the hill.

This is the story of the people, places, and events that made Pittsburgh's South Side the heart of the great Industrial Revolution. It is the account of the powerful industrial giants who owned the mills, men like B. F. Jones, James Laughlin, and Andrew Carnegie. But it is also the story of immigrants who came in droves from Germany, Ireland, Scotland, England, and later from central Europe, Poland, Lithuania, Czechoslovakia, Serbia, Romania, and Italy. They crowded Carson Street with the sights and sounds of different languages and customs. These were the people who made the steel that built America. This is their story, a story of steel mills, inclines, planes, trolley cars, saloons, and the crowded row houses where they raised their families.

One

The Glass Capital

of America

In the early to mid-1800s, the South Side was known as the center of the glass industry in America. The glass industry grew like wildfire. At the height of the industry there were nearly 80 glass factories in Birmingham. South Side glass was recognized as the finest in the country. Presidents Andrew Jackson and James Monroe ordered glass tableware for the White House from South Side companies.

Gen. James O'Hara and Maj. Isaac Craig were the pioneers of the glass industry in Pittsburgh. In 1797, they opened the first glass factory in the county. It was located on the South Side near the present day Duquesne Incline parking lot. They hired William Eichbaum from the Schuylkill Valley near Philadelphia to build the plant. Glassmaking was new on the western frontier, and they needed the experience of a German glassmaker. On the first day of operation, General O'Hara joked in his diary, "today we made the first bottle at a cost of $30,000." By 1807, they were doing over $78,000 worth of business. By the 1920s, most of the glass factories had moved away due to higher taxes and lack of room to expand.

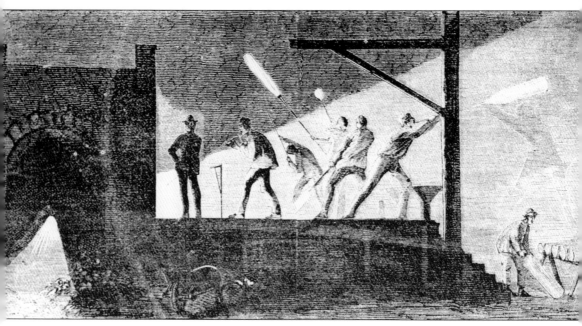

This illustration of men blowing glass in 1797 shows that glassmaking and shaping was difficult work. The heat of the liquid glass often reached 100 degrees Fahrenheit. The basic ingredients of glass are sand, which originally came from a sandbar in the middle of the Monongahela River, and potash (potassium carbonate), which came from wood ash and lime from limestone quarries where it was crushed into a fine powder. The most expensive glass was the dark red glass of railroad-warning lanterns. Pure gold was added to the mixture to produce the unique red color.

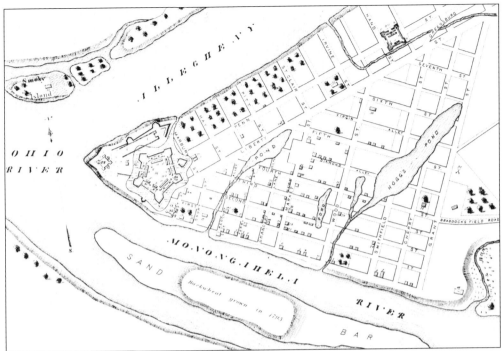

A map of Pittsburgh in 1795 indicates the sandbar in the middle of the Monongahela River, which was used for the manufacture of glass. During low water, it was possible to walk across the river. The note says, "Buckwheat grown in 1795." Maj. Gen. John Ormsby and Dr. Nathaniel Bedford were living in Pittsburgh at this time, but the South Side of the Monongahela was still undeveloped.

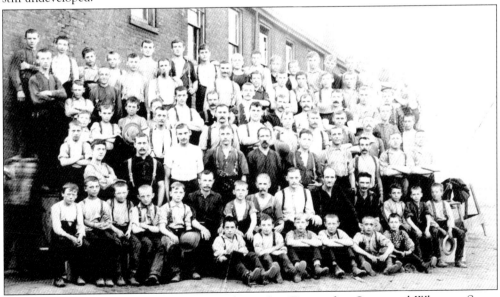

The employees of the Bryce Glass Factory located at Twenty-first Street and Wharton Street gather for a photograph in 1887. Notice how young some of the workers are. In 1887, it was not uncommon to start work in the factories at nine years old. Suspenders and bowlers were the style of the day. One can still see these old factories located all over the South Side.

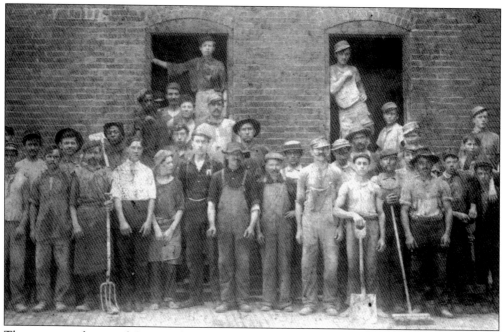

These are employees of Cunningham Glass, located at 900 Carson Street, in 1890. William Cunningham founded the company in 1850 to make window glass, flint glass, and druggist glassware. The main showrooms of the glass industry were in downtown Pittsburgh, but the factories were located on the South Side.

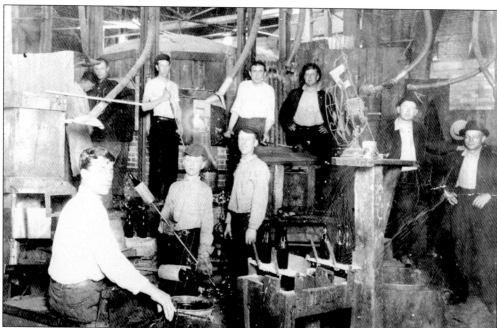

This is the interior of the Cunningham Glass Factory in 1914. At this time, most of the glass tableware in the United States was produced on the South Side. The factories produced all kinds of glass, including bottles, gas lamp shades, and window glass. One of the glassmakers is sitting on a box of Old Dutch Cleanser.

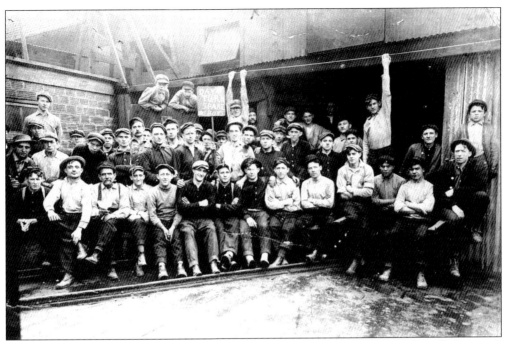

The "Day Turn Spare Boys" at the King Glass House are waiting their turn to be called to work whenever there was an opening. Some of the boys want to be noticed by hanging from the gutter of the building, others made a sign to identify their group.

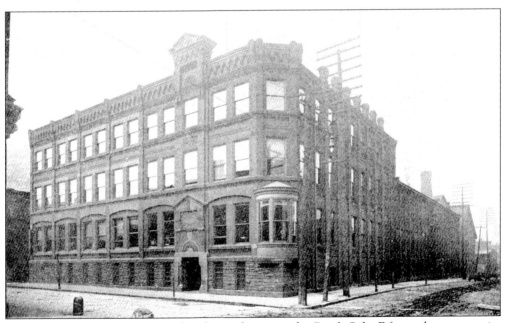

By 1891, it was time to organize the glass industry on the South Side. Fifteen glass companies formed a conglomerate known as the United States Glass Company (USGC), whose headquarters building can still be seen on the corner of Ninth and Bingham Streets. It is now used by the Salvation Army. The USGC became so powerful it was said to control the glass industry in the country.

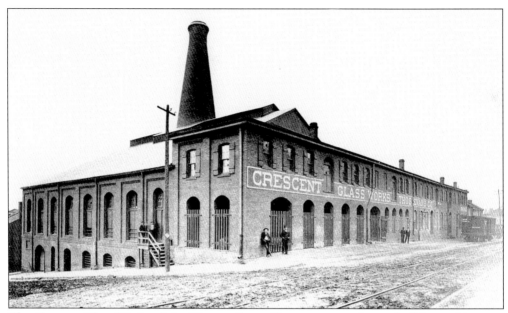

The Crescent Glass Works of the Thomas Evans Company manufactured oil lamp chimneys, lamps, globes, and jars. It was located at Eighteenth and Joseph Streets. Notice the size and shape of the chimney. The South Side was known for its glass factory chimneys, the highest reaching 110 feet above the ground.

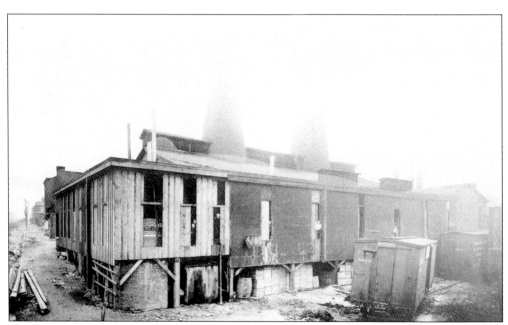

Shown is the Crescent Glass Works in disrepair in 1889. By this time, the glass factories on the South Side began to close due to increased taxes and lack of room to expand. Many of the workers moved out of state, where they were given cash bonuses to relocate their work.

Two

THE WORKPLACE OF THE WORLD

At one time, Pittsburgh's South Side was known worldwide as the center of the iron and steel industry, and nobody made more or better iron and steel than the Jones and Laughlin Corporation. Blast furnaces, called Eliza furnaces, were located on the north side of the Monongahela River and were connected to the open hearths on the South Side by the Hot Metal Bridge. By 1916, J&L had six blast furnaces and nine 200–250 ton open furnaces. By 1929, J&L was producing 1.74 million tons of steel ingots each year.

However, the prosperity of the steel mills on the South Side ended in the 1960s. By then, the steel industry was in economic trouble due to foreign competition. The depressed steel market of the 1970s led to a rapid decline in steel production and J&L began to demolish its older buildings. By 1989, the South Side Works were leveled and the steel industry was gone.

Today, the stores and upscale restaurants of the South Side Works have been developed on the land where the mills of the immigrant steelworkers once stood. One can drive across the Hot Metal Bridge, eat lunch at the Cheesecake Factory, or buy jeans at American Eagle, all on the site where immigrant workers once produced the iron and steel that built America.

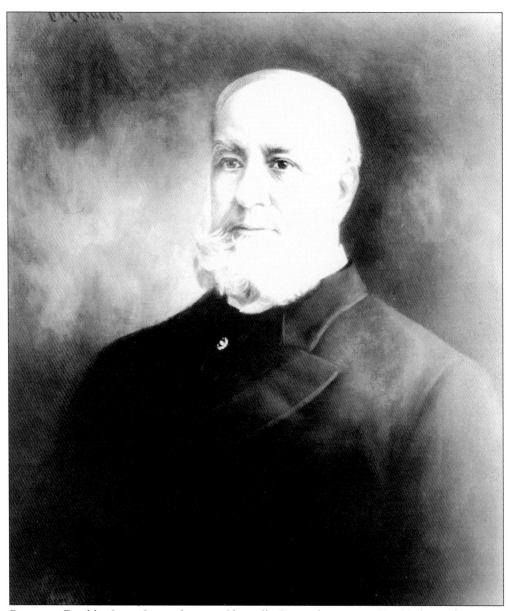

Benjamin Franklin Jones Sr. was born in Claysville, Pennsylvania, in 1824. He began his career as a clerk with Samuel M. Kier's canal boat company at the age of 18. In 1853, with Kier's financial help, he joined Bernard and John Lauth to operate the American Iron Works. Jones eventually became the owner of the American Iron Works, along with another partner, James Laughlin. The two of them built an iron company during the American Civil War, at a time when the northern army was in great need of iron for the war effort. In 1902, the partnership became a corporation, the Jones and Laughlin Steel Company.

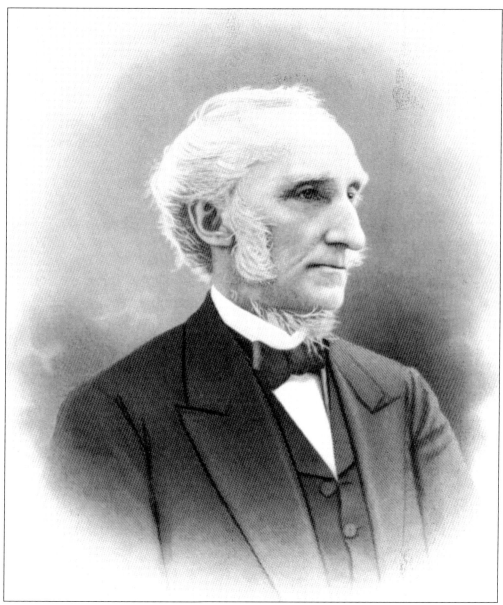

James Laughlin was born on October 31, 1806, and grew up to become a prominent Pittsburgh banker. He left the banking business in 1856 to become a partner with B. F. Jones and John Lauth in the American Iron Works. During the American Civil War, the company prospered as they supplied iron to the Union Army. After the war, iron was in demand during the railroad boom, which fueled the expansion of America. In 1873, steel was made for the first time at the Jones and Laughlin South Side Works. By 1884, J&L was completely out of the iron business and made only steel using the new seven-ton Bessemer converter, and by 1940, the Jones and Laughlin Steel Corporation covered over 100 acres in the South Side.

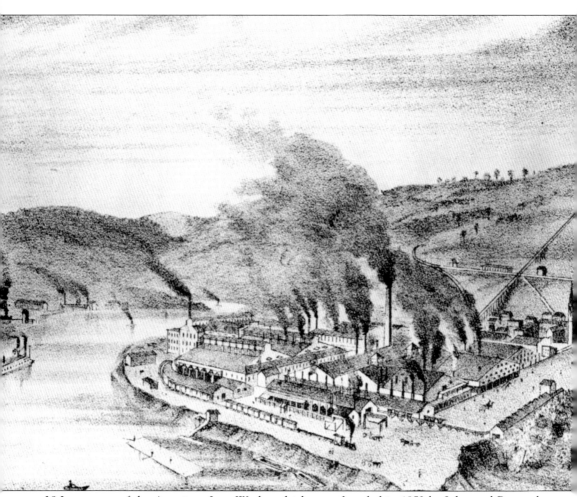

J&L grew out of the American Iron Works, which were founded in 1853 by John and Bernard Lauth. The Lauth's were ironmasters from Germany. Four months later, Benjamin F. Jones and Samuel Keir joined the company. Each man was given a 25 percent controlling interest. The American Iron Works eventually became the Jones and Laughlin Steel Corporation. Here is an early illustration of the American Iron Works. In the background to the right is an incline, which went from Twenty-second and Josephine Streets to Arlington Heights. There is also a road, which is possibly Josephine Street, and a very sparsely populated South Side slopes.

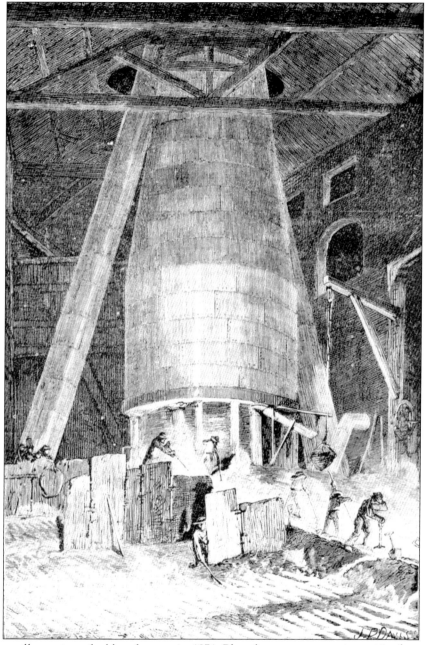

This is an illustration of a blast furnace in 1874. Blast furnaces remove impurities from metal. They are made of a chimney like structure that stands 80–100 feet high, which is made of iron or steel and lined with fire brick. The chimney is narrow at the top, increases in diameter in the middle, and is narrow at the bottom to form the hearth. The furnace is fed from the top with a mixture of ore, coke, and limestone. Preheated compressed air passes upward through the mixture, which removes impurities from the molten mass. As the process continues, the molten iron sinks to the bottom. The impurities, called slag, float to the top. The slag is drained off and the iron is tapped from below. The product is known as pig iron, which is converted into steel by the open hearths.

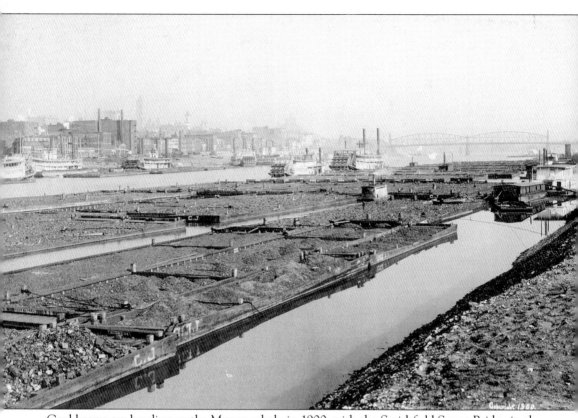

Coal barges are heading up the Monongahela in 1900, with the Smithfield Street Bridge in the background. Paddle-driven steamboats are pushing the barges and docking at the Monongahela Wharf. Initially, the mills got their coal from the hills behind the flats, but when those veins were worked out, coal was brought from points as far away as Lake Superior.

After World War II, Adm. Ben Morell served as president and CEO of Jones and Laughlin. Starting in 1950, he oversaw a postwar modernization of the plant. Under his leadership, there was a major expansion of the steel industry in the South Side. The new construction in 1951 shows the open-hearth chimneys being built, framing the railroad tracks that provided the fuel for the furnaces.

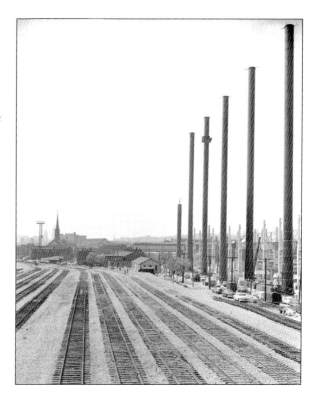

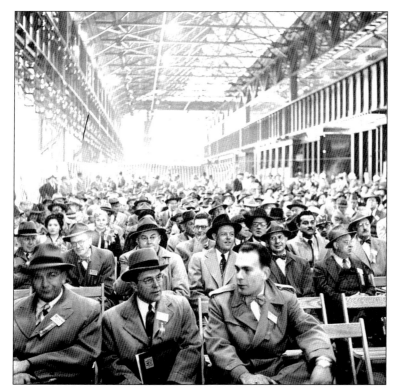

This is the celebration of the opening of the new open-hearth ovens as the heat was first tapped at the South Side Works in 1951. At the time, the steel industry was still growing. By the 1960s, it would see a dramatic decline.

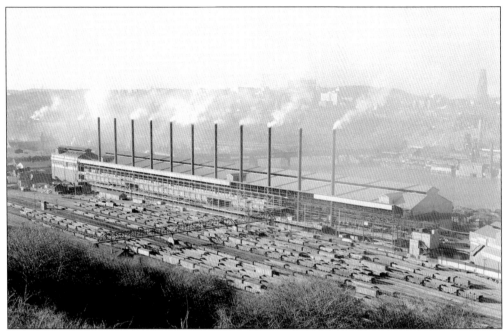

The great chimneys of the open-hearth furnaces stand like sentinels guarding the mill. The open hearth made the production of steel faster and easier. Nine 200–250 ton open-hearth furnaces were added in the early 1950s. Hundreds of railcars are gathered in the foreground to move the coal to the open hearths.

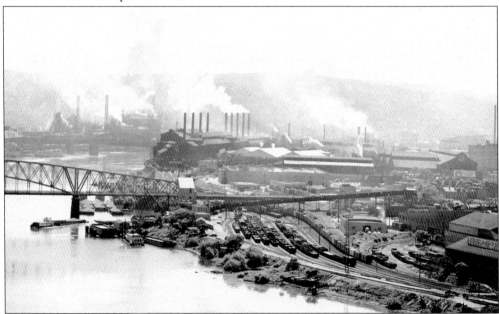

This is a view looking across the Monongahela River toward the Jones and Laughlin Steel Corporation and the South Side in 1951. The significant amounts of pollutants the mills have put into the air and water can be seen. The South Side was a dirty place to live. It was nearly impossible to see a clear blue sky or the sun shining brightly. If someone lived on the South Side it was because they worked there.

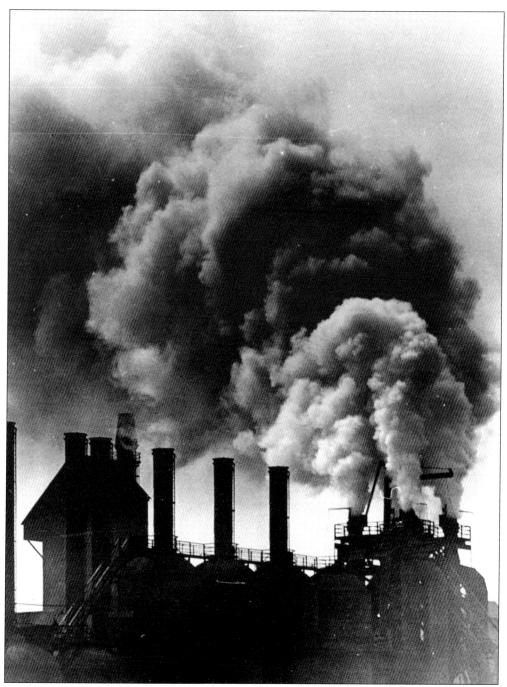

Smoke emissions from the Eliza blast furnaces show the extent of air pollution prior to the smoke control programs of the 1950s. Fifty years ago, the smog was so bad there were days when the sun could not be seen. Because of the smoke, historian James Pauton wrote "Pittsburgh is smoke, smoke, smoke—everywhere smoke—by night it was Hell with the lid taken off."

This is Liberty Avenue in downtown Pittsburgh at 9:00 in the morning in 1945, before smoke pollution laws were in place. There were nearly 1,300 manufacturing factories in operation, which made Pittsburgh famous as the Smokey City. In 1947, the Allegheny County Board of Commissioners appointed a smoke control committee to regulate the air pollution.

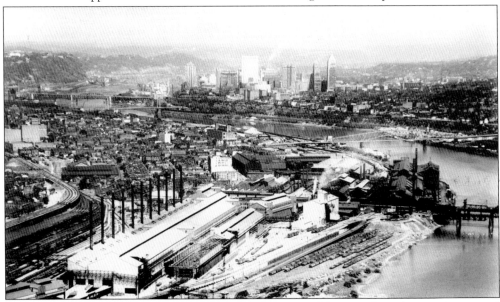

This is a view of the mill in the 1950s, with the chimneys of the open hearths pointing toward downtown Pittsburgh. The county smoke control ordinance had cleaned the air. J&L remained an independent steel company, with either a Jones or a Laughlin descendent controlling the corporation. This independence ended with the merger of J&L with the French, Ling-Tempco-Vought Corporation (LTV) in 1974. By then, the steel industry was collapsing, and by 1989, all of the mills were closed and the buildings were gone.

Three

THE PEOPLE
WHO BUILT AMERICA

The story of the South Side is the story of immigrants from Europe. These fiercely independent people came from Germany, Ireland, Scotland, England, and later from central Europe, Poland, Lithuania, Czechoslovakia, Serbia, Romania, and Italy. From 1892 to 1924, 12 million immigrants passed through Ellis Island; 9 out of 10 were Europeans. They were welcome in this country as long as they could show they could work in the mills and factories. Most of them never set foot in New York City. They left Ellis Island on trains or boats as quickly as they landed to find work or relatives who were already living in America.

These were the people that fueled the industries of America. They came to Pittsburgh to make iron and steel for the factories of the Industrial Revolution and most importantly, for the railroad tracks that would stretch across the country like a giant spiderweb. They were committed to a fair day's work for a fair day's wages, raising healthy families, and building a better future. In 1941, author Thomas Bell wrote *Out of this Furnace*, a book about the steel industry in Pittsburgh. In it he wrote that these were the people who "with their blood and lives helped to build America, that the steel they produced changed the United States into the most industrialized nation in the world."

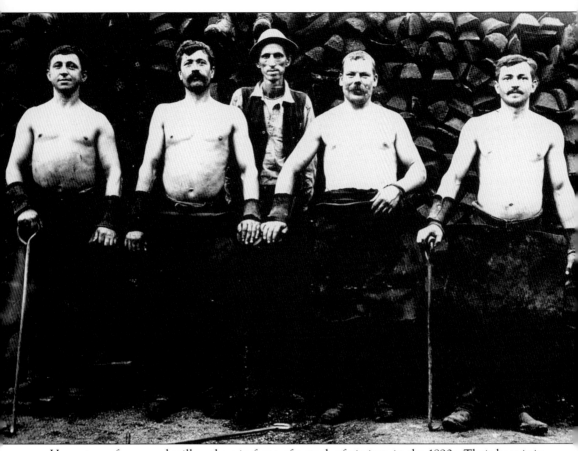

Here we see four proud mill workers in front of a stack of pig iron in the 1890s. Their boss is in the background. Work in the mill was difficult and dangerous. A typical shift was 12 hours long, 7 days a week, with two days off a year—one on the Fourth of July and the other at Christmas.

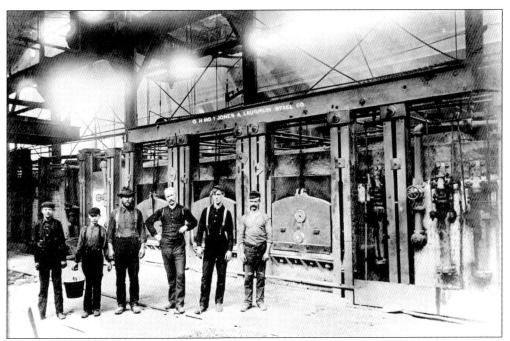

The caption on the back of this image of open hearth No. 1 furnace crew in 1900 reads as follows: "1. 2. "Weasel" Onieger, 3. George "Whiskers" Fehrens, 4. William Bost, Rodger Dowling, weight master (killed in auto accident) 6. Tommy Kusick, 2nd helper.

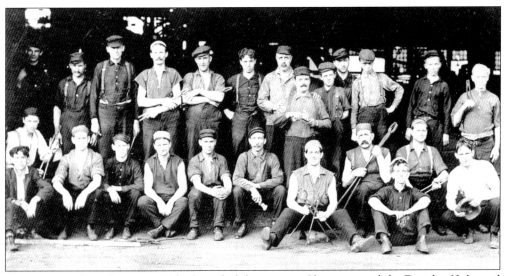

These J&L mill workers in 1906 had two holidays a year, Christmas and the Fourth of July, and were paid a stunning wage of $2 per day. They often said that work in the mill was "half time hot, half time cold, and half time miserable."

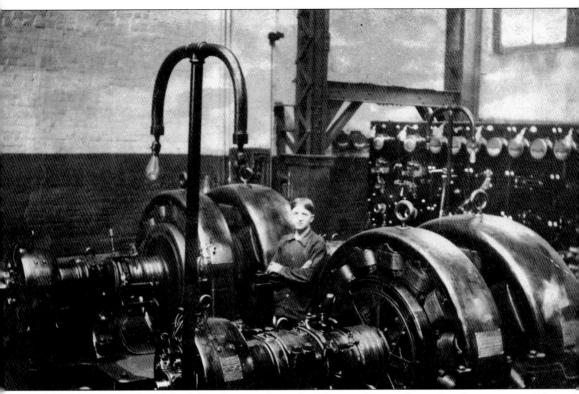

The caption on the back of this photograph reads, "Vincent Banaszak standing between two 60 cycle AC motor generators built by Westinghouse in the South Side power house about 1907." The two generators provided electricity and light for the Jones and Laughlin South Side Mills.

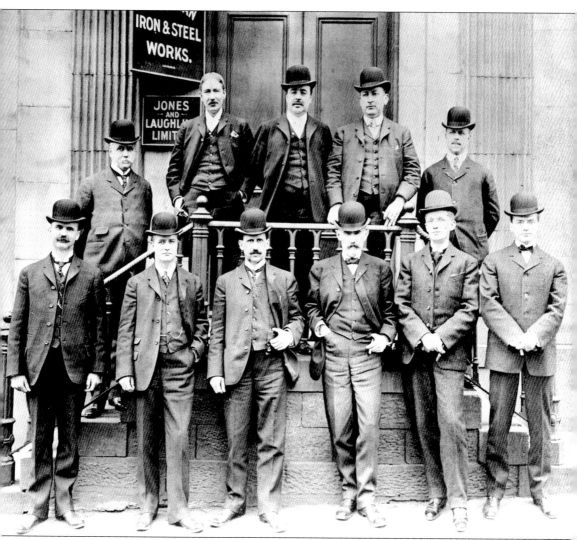

By 1900, J&L was doing business all over America. These national sales agents gather at the entrance of the general office on the South Side in 1904. Pictured here from left to right are (first row) H. F. Holloway, New York; F. H. Holt, Detroit; W. M. Kelly, Atlanta; George Kinsey, Cincinnati; Frank M. Campbell, Philadelphia; and William Armstrong, St. Louis; (second row) David N. Barker, Chicago; A. B. Marble, Boston; W. F. Bonnel, Cleveland; William Best Jr., San Francisco; and George Beals, Buffalo. This photograph gives an idea of business dress of the day. The bowler hat was clearly the choice for the fashionably dressed man or "dandies," as they were called.

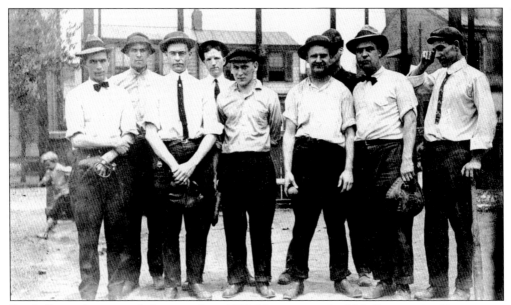

Baseball was the sport of choice in June 1913. Here we see the J&L Engineering Department Baseball Team. Almost every department in management had a team. The laborers did not. They were working too hard.

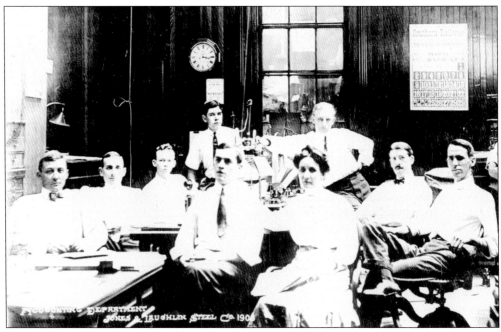

You can see the August 1908 calendar on the wall as these members of the J&L Accounting Department pose for a picture. It is 3:00 in the afternoon, and these employees are proud of their position of importance in the steel industry. Many of them seem young, bright, and invincible.

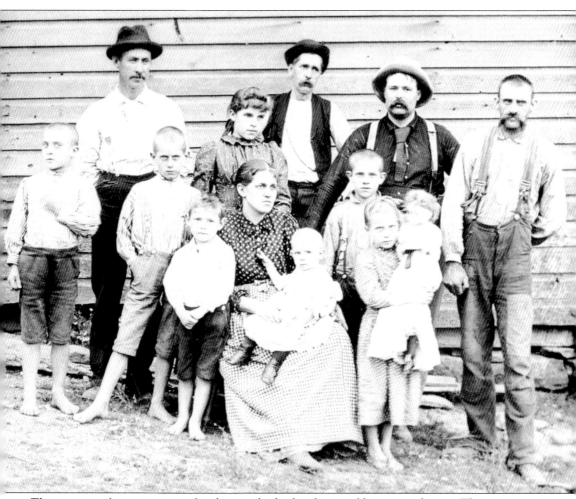

This picture of an immigrant family reveals the harshness of living conditions. The men go to work in the mills. The women take care of the home and children. Feet are bare, there is little food, and mom and her daughter wear the same material which mom probably made. The family probably did not speak English, read or write, or know anything about the culture they had entered. They did their shopping at a six story massive brick building with bronze plates at the corner of Carson and Twenty-sixth Streets called the Pittsburgh Mercantile Company. The workers called it the "Pick Me Store." Illegally owned by J&L, when the credits equaled or exceeded the value of the wages, the paycheck went to the mercantile store, in essence making the workers indentured servants to the company.

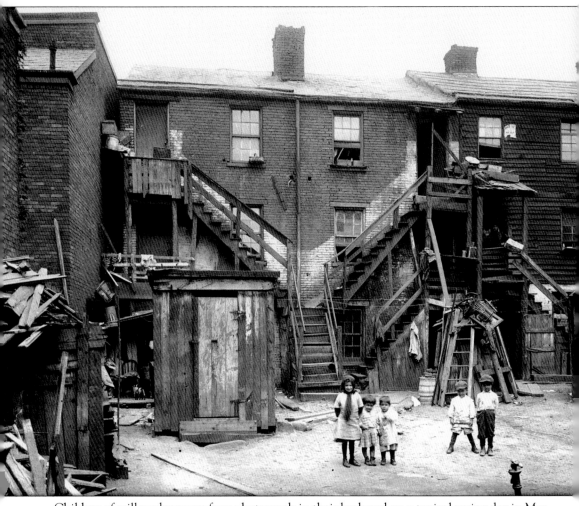

Children of mill workers pose for a photograph in their backyard on a typical spring day in May 1914. Conditions were deplorable for most workers and their families. Working 12-hour shifts, 7 days a week, the men had little time to maintain a household. Women and children can be seen peering out from doorways and windows. There was a desperate need for water, which was carried in buckets to the apartments. There is a common water pump in the foreground. All the families shared the same out-house facilities. There were no iceboxes to keep the food healthy. Piles of scrap wood were used for warmth and cooking. The rental properties were rarely updated or cared for by the landlords. In 1914, 85 percent of employees were non-English speaking, placing them at a terrible disadvantage in moving beyond their present living conditions.

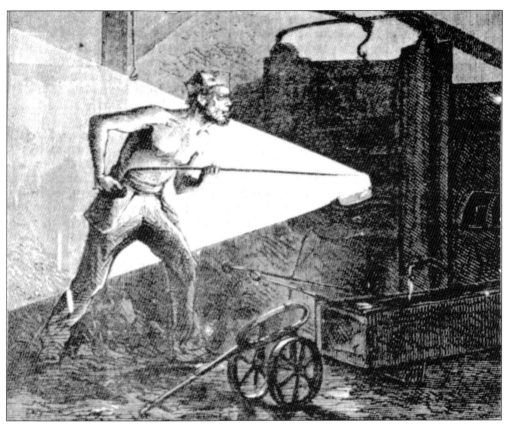

Between 1860 and 1867, the Sligo Iron Works did something unique by having their employees photographed by the Cargo Photographic Rooms Company. Photography was still in the early stages of development, and it was during this period, sparked by the Civil War, that photography began to grow as a means of recording history. Prior to this time, people looked at illustrations like this one of a "puddler" working molten iron.

Col. John R. Lyon was one of the founders of Lyon, Shorb and Company in 1852, also known as the Sligo Iron Works. The company was located beneath the Smithfield Street Bridge. At this time, Sligo had 30 employees. By 1879, the company employed 250 men and had 25 puddling furnaces.

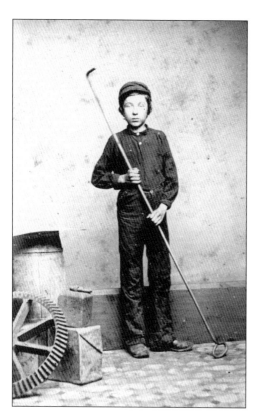

P. Myers worked for the Sligo Iron Works as an assistant bundler, or assistant shear man, in 1862. He is posing with his tools and wearing his work clothes. He is probably between 9 and 12 years of age and standing as still as he possibly can for the photographer.

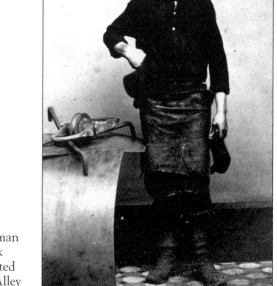

John Steiner is listed as an assistant shear man at Sligo. He is posing in his apron and work clothes with the tools of his trade. He is listed as living on McClurg Street near Larkins Alley in what was then East Birmingham.

F. "Salty" Hart was an assistant roller at Sligo Iron Works. The assistant roller was involved in the production of muck bars of iron that were already purified. The Lyon, Shorb and Company banner is on the barrel.

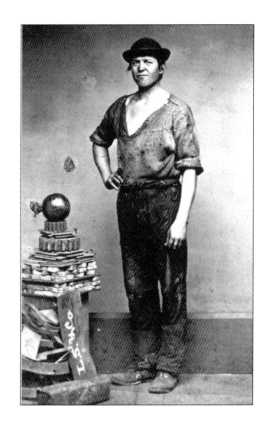

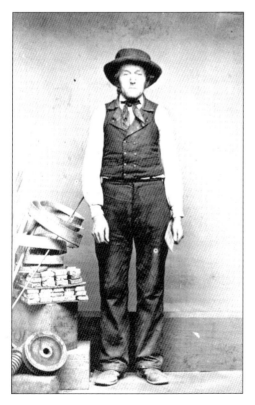

H. Epping worked at Sligo as a pile maker. The 1864–1865 Directory of Pittsburgh and Allegheny Cities lists Henry as a glassblower living in Saint Clair Township, which was then located near Mount Oliver.

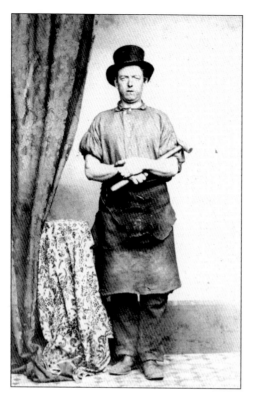

In 1864, John Peeples worked at Sligo as a blacksmith. Here we see him in his work clothes. John lived at 24 Carson Street. Notice his shoes. In those days, there were no left or right shoes. One simply wore them until they formed to their feet.

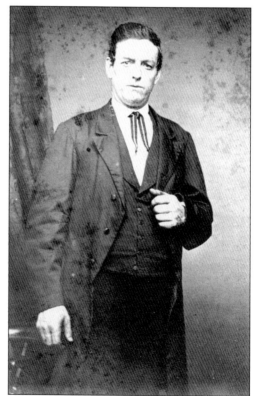

Here can be seen what appears to be the same John Peeples posing in his dress clothes. What an amazing difference. Every worker wanted a set of dress clothes for special occasions and for pictures to send back home.

M. Cunningham is listed as a helper and laborer at Sligo. He lived at 33 Carson Street in what was then West Pittsburgh.

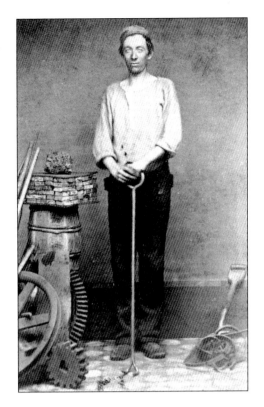

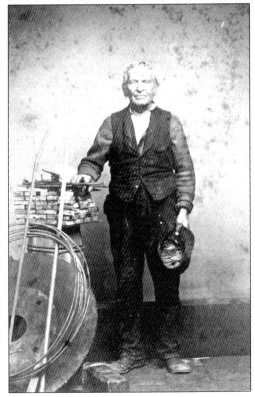

George Keil is listed as a pile maker. He lived at 32 Carson Street, next door to M. Cunningham, and worked in the same department as H. Epping.

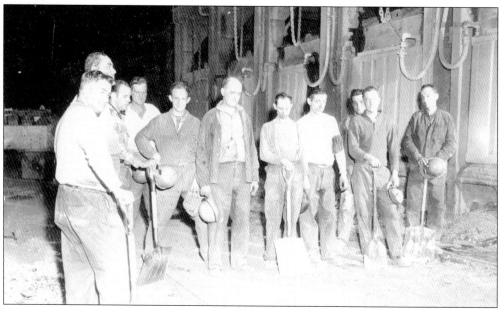

These men worked in the open hearth shop in 1955. By then, the open hearths employed laborers on three swing shifts, 8:00 a.m. to 4:00 p.m., 4:00 p.m. to midnight, and the graveyard shift, from midnight to 8:00 in the morning. Workers rotated to a different shift each week.

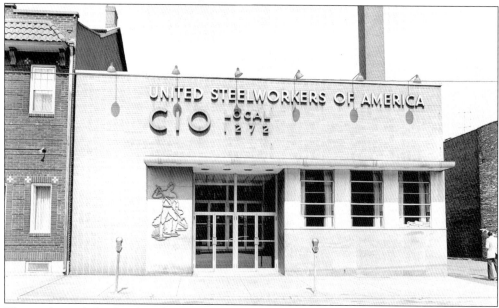

The workers of the South Side were union people. They began organizing against working conditions and pay in the 1880s. Until then, industry strong-arm tactics blocked workers attempts to organize a union. Management could "black-ball" a worker if his attitude was "bad" towards the company. A strike in 1897 at the Carnegie Company in Homestead finally resulted in a contract. After a fierce battle, seven workers and three Pinkerton watchmen were killed. It was not until 1936 that the Steel Workers Organizing Committee was organized in Pittsburgh with 125,000 workers in 154 lodges. This local headquarters No. 1272 of the United Steel Workers of America is located at 2325 Carson Street.

Here we see a steelworker using a foundry ladle to pour molten steel into ingot molds.

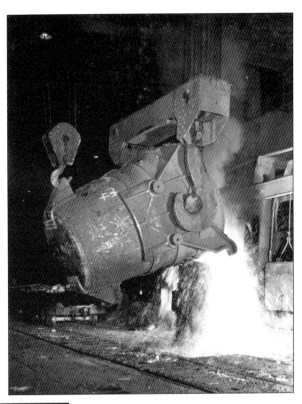

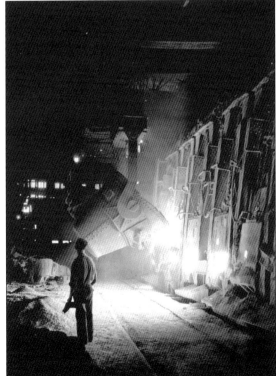

A solitary steelworker watches molten steel being poured into an open hearth for refinement. Often times, because of the noise and the size of the mill, steel making was a lonely job. The giant ladle hangs from the overhead cranes where it is moved up and down the open hearth line.

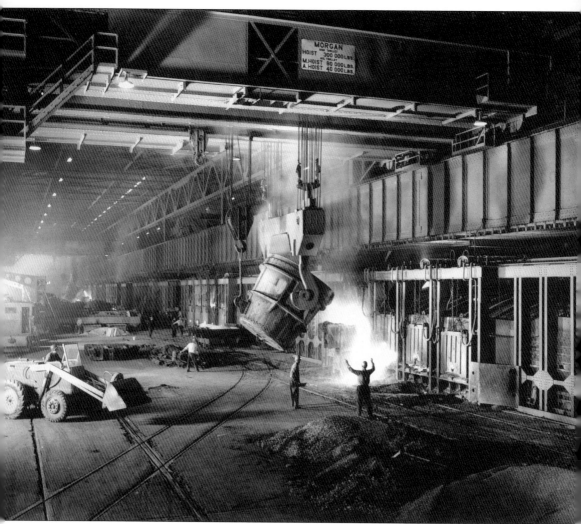

An interior view of the mill shows a ladle pouring molten steel into an open-hearth furnace. The huge overhead cranes were run by an operator who had the lives of the workmen below in his hands. The vast openness of the mill was filled with unrelenting noise, the constant smell of oil, and danger from the giant equipment.

Four

THE TROLLEYS
AND INCLINES

The South Side in the early 1800s was a five-mile-per-hour world. A person could travel no faster than a horse or wagon could carry them. Then things changed. First came the horse-drawn trolley, then cable traction cars, and finally the electric trolley.

Then there were the incline planes, which actually moved people straight up a mountain. The idea of the incline is to use the counter balance principle. Two cars of equal weight at each end of the cable take turns pulling each other up and down the track.

There were six inclines on the South Side. The Duquesne Incline opened in 1877 and ran from West Carson Street near the Smithfield Street Bridge to Duquesne Heights, or Mount Washington. The Monongahela Incline, built in 1870, connected West Carson Street with Grandview Avenue. The Duquesne and Monongahela Inclines are still in operation today. The Castle Shannon Incline No. 1 opened its doors in 1890. It ran from Carson Street near Third Street to Bailey Avenue. It closed in 1941. The Knoxville Incline opened in 1890 and traveled from Eleventh Street to Warrington Avenue. It closed in 1960. Next to the Knoxville Incline was the Mount Oliver Incline, which was constructed in 1871 and ran from Twelfth Street and Bradford Street to Warrington Avenue at the top Mount Oliver. It closed in 1951. The St. Clair Incline opened in 1886. It went from Twenty-second and Josephine Streets to Arlington Heights. It closed in 1935.

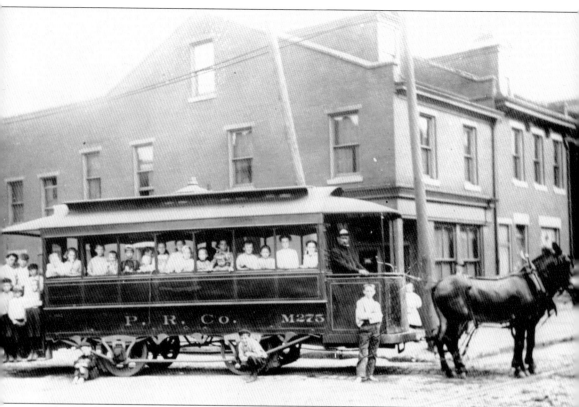

The Pittsburgh Railway Company horse-drawn trolley car traveled down Sarah Street, across the Birmingham Bridge and along Second Avenue to downtown Pittsburgh. The trolley seated 14 passengers and was lit at night by a pair of oil lamps at either end of the car. In winter, there was a thick covering of straw on the floor to keep the passengers feet warm. A single driver controlled the harness of the horses and directed the speed as the wheels traveled in tracks. The children are standing on the steps and kneeling by the wheels in this posed photograph. Horsecars operated in the South Side until 1923. At the time, horse droppings were common in the streets, and in the summer the smell was nearly unbearable.

The *Pittsburgh Dispatch*, November 30, 1922, reported, "13 year old patient Clinton Seeley of 1906 Sidney Street, risked his life to save Spotty, his fox terrier from death beneath a street car. While making the rescue, Clinton was hit by another car and suffered a compound fracture of his left leg and was treated at South Side Hospital. Since then, Spotty has been trying to break up the dangerous sport of 'stealing' or 'hopping' rides on the street cars."

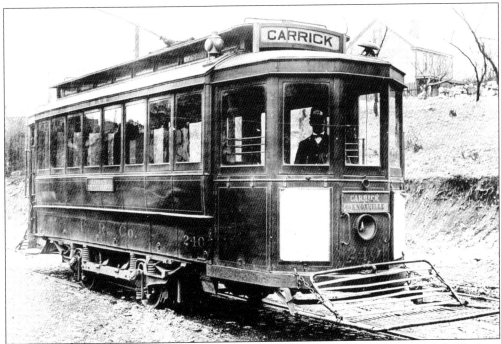

The Carrick and Knoxville Electric Trolley, around 1890, had a cattle thrower on the front to guard against dogs, goats, and cattle in the street. The opera advertisement on the front reads, "Shutz, Ringwalt Mission of St. John, Choral Union, Carnegie Hall, Thur. Eve."

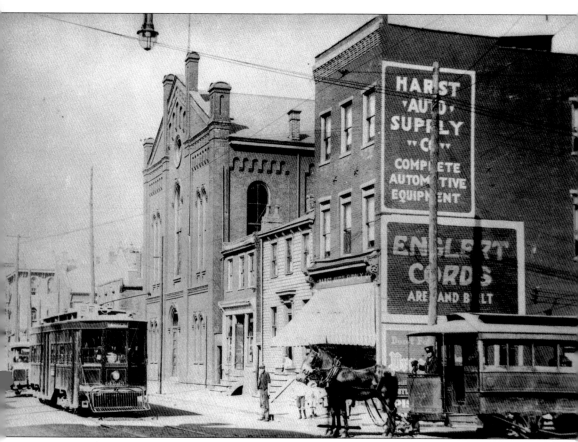

A horse-drawn trolley and an electric trolley meet at the corner of Eighteenth and Sarah Streets in 1915. This view is looking north toward the Polish Falcons Club. On April 4, 1917, a speech was given by I. J. Pederewski to delegates at a convention of the club to recruit a Polish army to fight in Europe with the allies in World War I. The Polish Falcons Club is still active today.

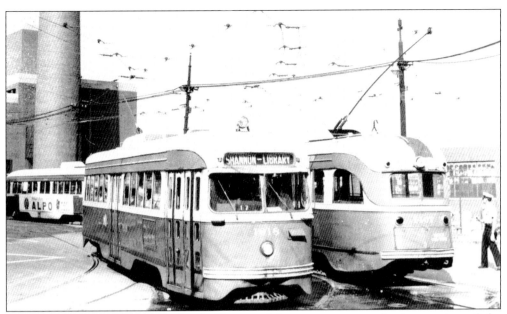

Rush hour in 1956 shows the Castle Shannon-Library streetcar at the intersection of the Smithfield Street Bridge and Carson Street. Notice the maze of overhead wires that make the trolley system work.

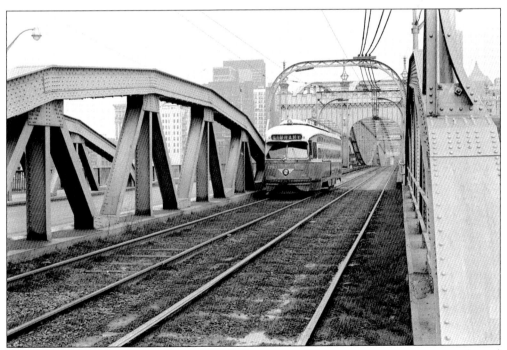

The electric cars turned into what were called streetcars. They were a common means of travel around Pittsburgh and the South Side. Here are streetcars traveling across the Smithfield Street Bridge, heading toward the South Side in 1967.

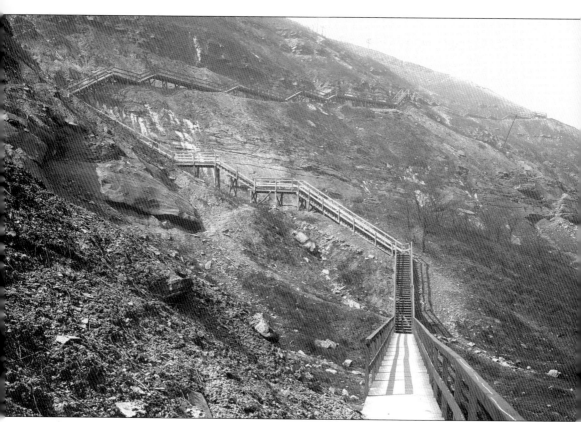

The "Indian Trail Steps," in this view looking west in 1911, led from the South Side near present-day Station Square to Duquesne Heights or what was later called Mount Washington, named after George Washington, who traveled here as a young surveyor. Before the use of incline planes, they were the primary means of travel to the top of the hill.

To get to the top of the steep cliffs of Mount Washington, a new method was needed other than climbing up the Indian Steps. Built in 1870, the Monongahela Incline is the oldest and steepest incline in the country still in operation. Its total length is 648 feet. At the time of this 1920s photograph, there were few houses on the top of the hill. The buildings at the bottom of the incline have been torn down exposing the retaining walls.

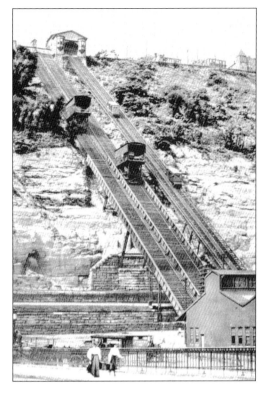

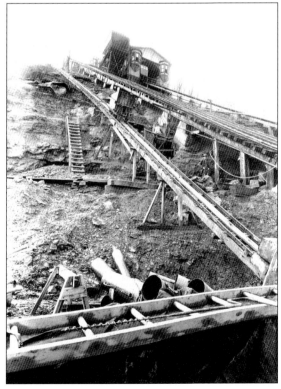

A view of the Monongahela Incline supports, looking toward Mount Washington in 1926, shows the infrastructure of the tracks as they climb the daunting hill. There were two tracks, the passenger line and the freight line. The freight line was closed in 1935, but the passenger line still remains open today.

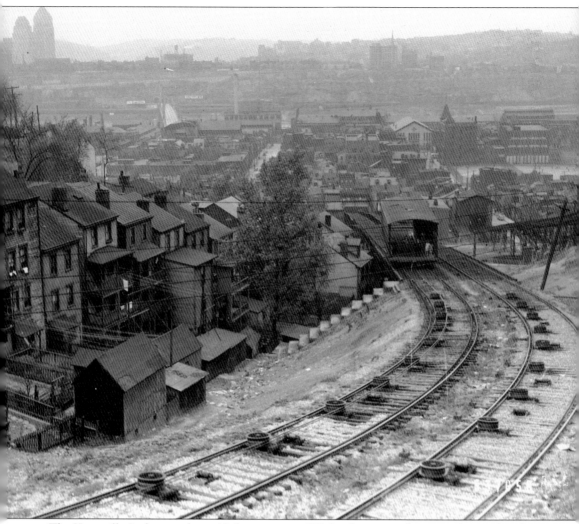

The Knoxville Incline made an 18-degree curve, 350-feet long, at a distance of 1,000 feet from the station located at the top. It was the longest incline in Pittsburgh with nearly a half mile of track. At one time it was the only incline in the world with a curve. It could carry 50 tons of horses, wagons, and passengers at a time. The cables are carried around the curve on pulleys, which can be seen located on each track. The huge cars, designed by John M. Roberts, were 16-feet wide, and 47-feet long. They sat on a triangular truck designed to carry 50 tons or more. The incline was heavily traveled both by walking passengers and horse and wagons. The fare was only 1¢. The incline was dismantled in 1961.

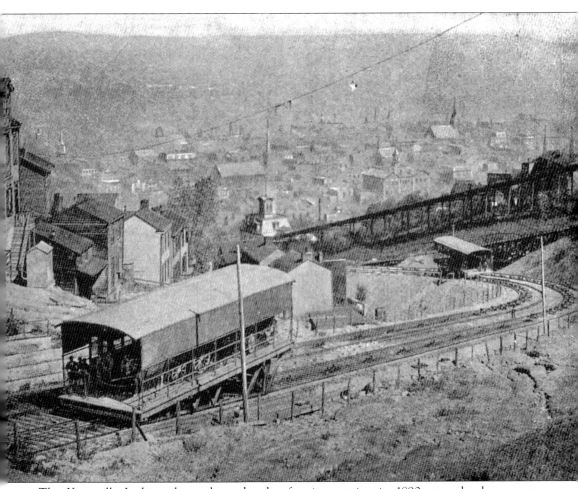

The Knoxville Incline, shown here shortly after its opening in 1890, was also known as the Twelfth Street Incline. It was located near the Oliver Incline, which can be seen in the background. The incline ran from Twelfth Street to Warrington Avenue and then to Knoxville Avenue on Mount Oliver.

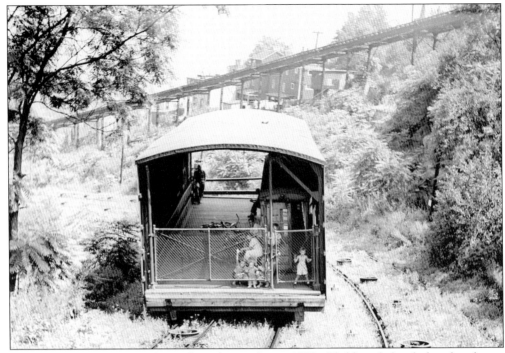

The Knoxville Incline is descending the tracks in 1950. Children behind the closed gate are looking out the back of the huge freight car. The Mount Oliver Incline can be seen in the background.

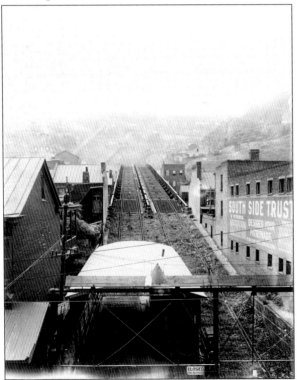

This is a view of the base of the Knoxville Incline sometime between 1890 and 1910. The incline was a double track railway with 60-pound rails on wooden ties resting on steel girders. Each car weighed about 10 tons and was designed to carry streetcars and other vehicles.

This is a view of the Knoxville incline descending to Twelfth Street and the Bedford Market in 1951, which was the last year of the incline.

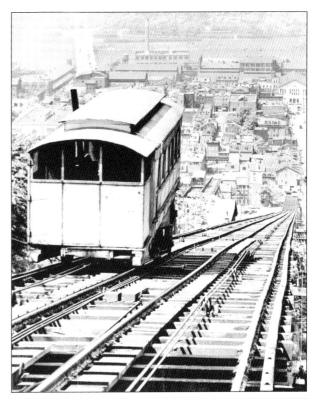

This is a side view of the entire Mount Oliver Incline sometime between 1890 and 1910. It went from Twelfth Street to Warrington Avenue on the top of Mount Oliver. The Mount Oliver Railways Company built the Mount Oliver Incline in 1871. It closed in 1951.

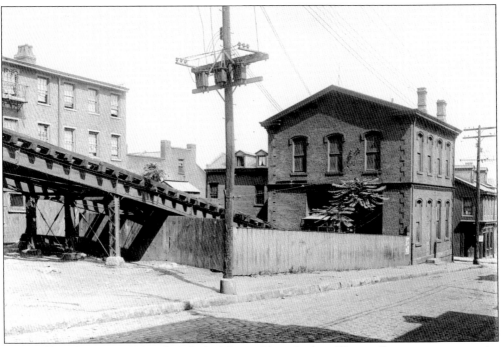

Pictured here between 1890 and 1910, the Mount Oliver Incline Waiting Station was two-stories high. The first floor was used for passengers and the top floor as offices. The station was located between Eleventh and Twelfth Streets.

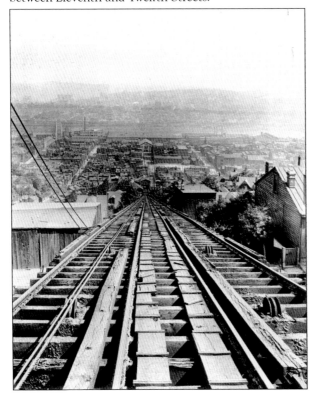

The Mount Oliver Incline, constructed in the summer of 1871, traveled from the Station and Engine House on Warrington Avenue, opposite Mount Oliver Street, to Twelfth Street where the market was located.

Five

THE STREETS
AND ALLEYWAYS

When Nathaniel Bedford asked civil engineer James Patterson to lay out the streets of Birmingham in 1811, there were great open fields surrounding the streets. By design the streets were narrow due to the small volume of travel and the open spaces of the wilderness. As the town grew, the streets were widened and offset beginning at Seventeenth Street, and called East Birmingham.

The boroughs of the South Side were defined by street boundaries. There was Birmingham (Sixth Street to Seventeenth Street), East Birmingham, (Seventeenth to Twenty-seventh Street), and Ormsby (Twenty-seventh Street to Beck's Run Road). Further west was South Pittsburgh (Coal Road to Sixth Street). To the west, down the Ohio, Temperanceville was the present-day west end. Knoxville was named after Jeremiah Knox's 1,250-acre fruit farm. Mount Oliver was named after Dr. Oliver Ormsby Jr., and Mount Washington was called Coal Hill until the end of the Civil War, when it was named after George Washington.

Carson Street is known for its Victorian-style buildings, erected during the reign of Queen Victoria of England (1837–1901). The Italianate style (1850–1880) is vertical in proportion with overhanging eves supported by large brackets made of wood projecting from the wall. The Second Empire style (1860–1895) was named after the rule of Napoleon III and is known for its mansard roof, named after the French architect Jules Hardouin-Mansart, which is a steep roof covered with cut slate, dormer windows, and brackets under the eaves. The Queen Ann period (1880–1900) is an elaborate style with a variety of colors. It mixes gables, round towers, and porches with decorative details in an asymmetrical design. The Late Victorian period (1885–1905) has a flat façade with corbelled brick, which are brick courses each built out beyond the one below. Romanesque (1890–1920) is often made of yellow brick with a cornice made with a three-dimensional pattern in the brickwork. Vernacular was used throughout the Victorian period and includes details from all the styles of the era. It is very simple in design with a flat façade and no projecting details.

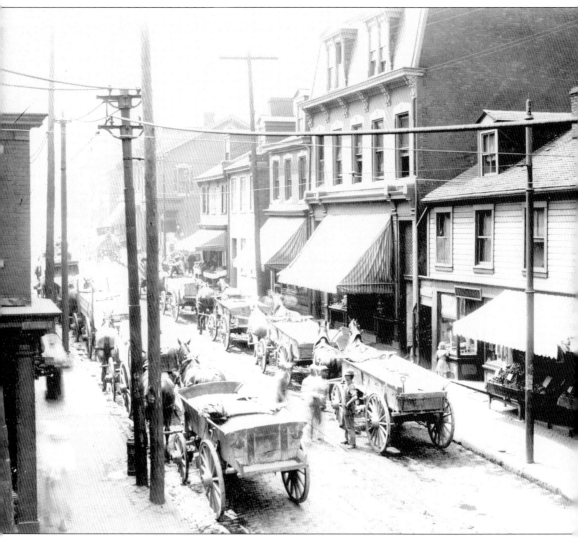

This is a typical day on Twelfth Street, as wagons are being loaded and unloaded, men are talking in the street, and awnings are stretched open to protect the stores from the summer sun. A young girl peers into a store window above the wagon at the bottom right, and trolley tracks can be seen in the middle of the street. Notice the Second Empire mansard roof on the three-story building and a vernacular wood-framed building to the front right. When walking around the South Side, it is important to look up. One will see many surprises and beautiful designs there.

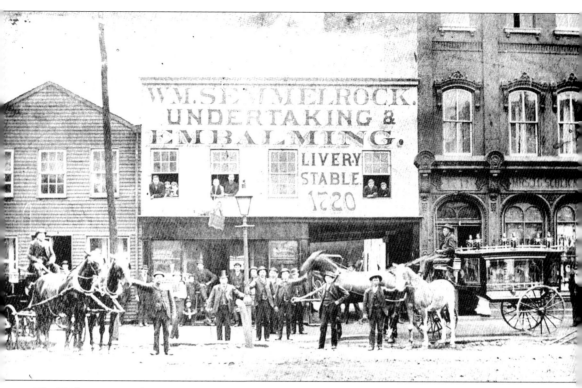

The William Semmelrock Undertaking and Embalming Company at 1720 Carson Street proudly displays a horse-drawn hearse. Gas lights line the street, and children are looking out the second-story windows. Families generally lived above the storefronts, with the business below.

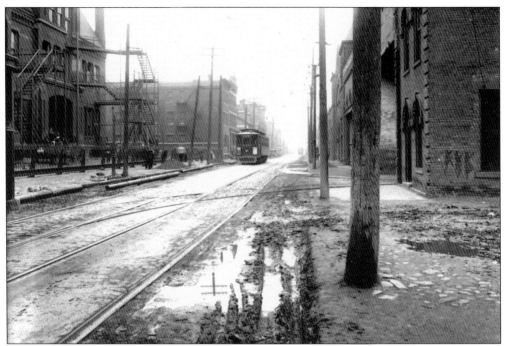

A look down Carson Street from the 3000 block in 1917 shows the muddy conditions after a rain. Carson Street was named after one of Nathaniel Bedford's friends, who was a sea captain living in Philadelphia. Originally, it was called the Washington Pike because it connected Pittsburgh and Washington, Pennsylvania. Wickerson School, on the left, was closed in 1949.

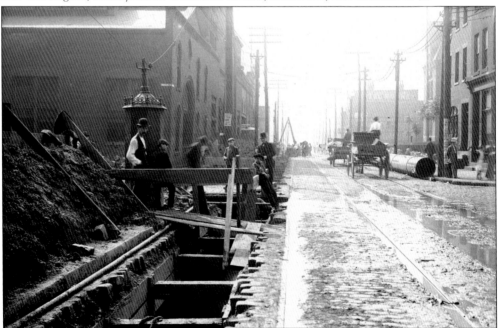

These men are laying 36-inch-steel sewer pipe, which can be seen in the background to the left near the horse-drawn buggy. The photograph was taken looking east at Thirtieth and Carson Streets, after a heavy rain.

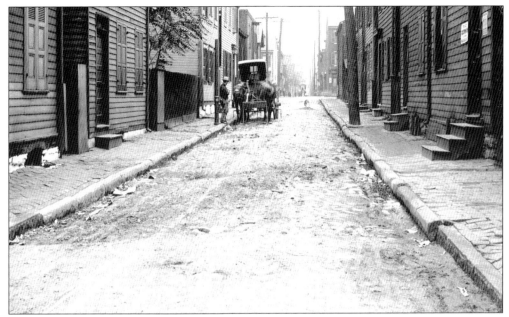

Alleys were a great place to live on the South Side. There was little traffic, children would play, and families would gather to create a unique community. Shown here is Larkins Alley in a view looking toward Twentieth Street in April 1909. Closed shutters, wooden steps, a water and hay trough, a lone dog in the street, and the proud owner of a horse and buggy can be seen.

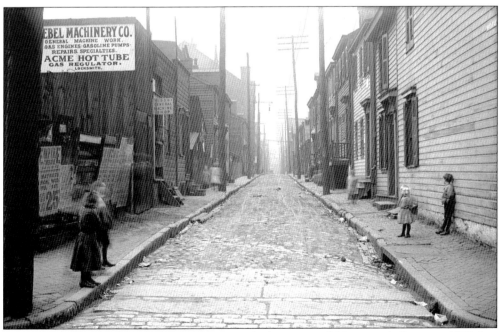

Wrights Alley and Twentieth Street, in a view looking toward Nineteenth Street in 1909, has an advertisement on the building for the Ebel Machinery Company and the Acme Hot Tube Company. There is also an advertisement on the wall promoting the "Empire Theater, Matinees, M-W-F-Sat."

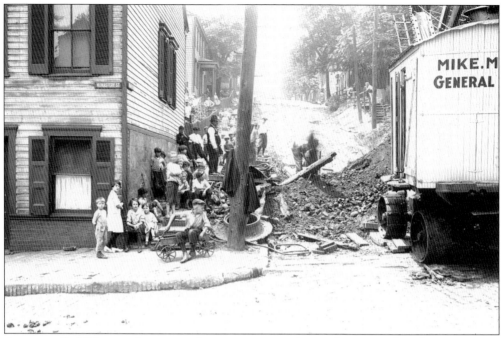

A group of children gather to watch street construction and a steam shovel in action on St. Martin Street, in a view looking south from Monastery Street in 1923.

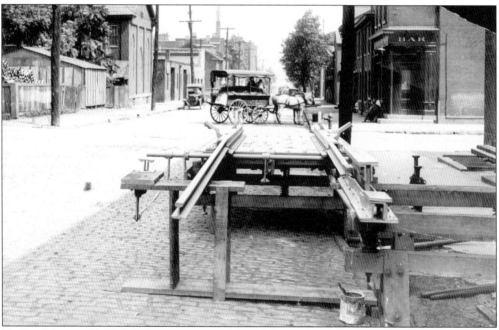

Phillips Mine and Mill Supply Company was one of the many businesses on the South Side. This photograph was taken at the corner of Twenty-third and Jane Streets in front of the Lutheran church with Liperts Bar in the background. The horse and buggy are at the water trough, and an automobile is parked in the background.

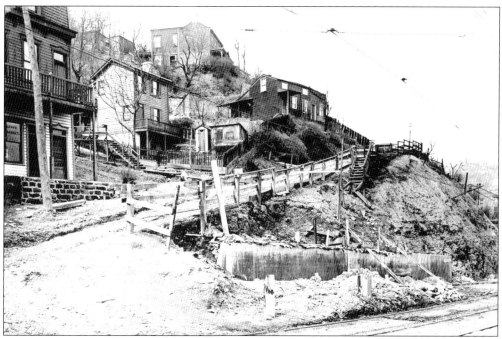

William Street winds its way up the hill from Arlington Avenue toward the present-day Liberty Tunnels, in 1922. The construction of a new retaining wall to make the turn possible is underway. For the South Side to develop, turns and climbs like this were necessary.

The steep climb of the Eighteenth Street reverse curve in 1911 shows a horse and buggy moving up the hill along the trolley tracks.

Eighteenth Street and St. Patrick's Road were steep, narrow, and dangerous. At the lower end of the fence, boys are sitting on a shed, watching the action as the horses pull the wagon up the hill. One of many Lorch's Store advertisements is to the right.

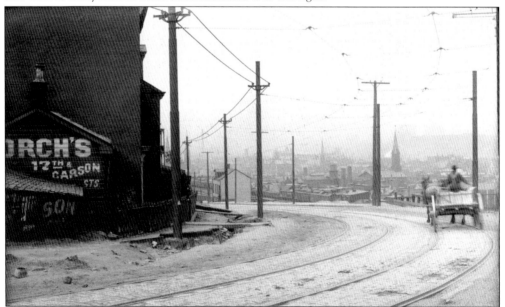

A lone horse and buggy make their way down Eighteenth Street, below Pius Street, toward Carson Street in 1911. Another Lorch's Store advertisement is to the left. There are electric trolley lines overhead, and you can see the spire of the churches of the South Side in the background.

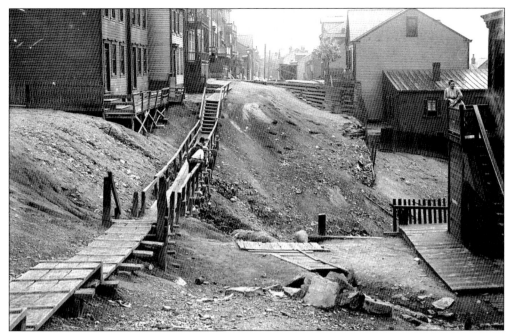

This is a unique set of images, which depict how streets were built in the early 1900s. On September 10, 1907, the city began a project to fill in the gully, which divided Mission Street on the slopes into two sections. The depression was so steep that only a wooden walkway could cross it. Notice the woman on the porch to the right.

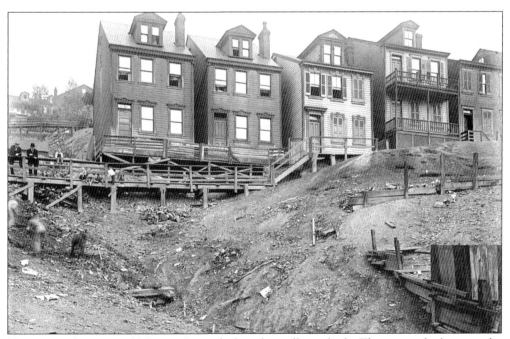

Here is another view of Mission Street before the wall was built. This one is looking up the hill at the depression. The same adults and children pictured in the previous image lean on the railing to watch the workmen.

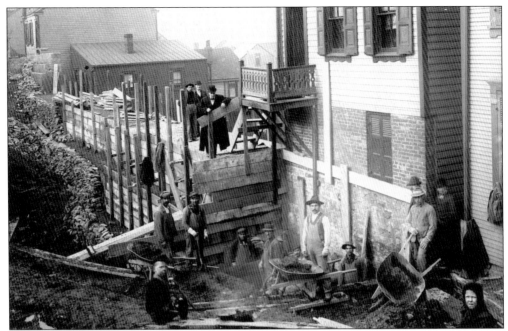

By January, the work had progressed to the buildings near Greely Street. All of the work is being done by hand, using picks, shovels, and iron-wheeled barrels. It is cold outside. The child in the foreground has his hood up, and the workmen hang their coats on the scaffold. The superintendent with the bowler hat at the end of the wall watches over the construction.

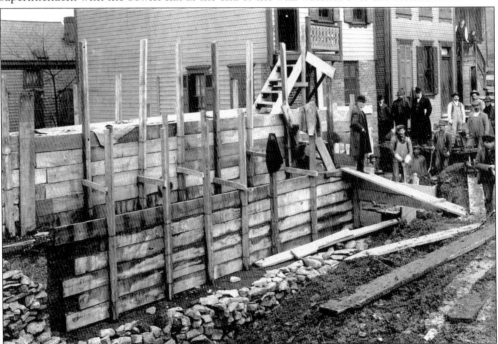

By December 1907, work on the street had progressed significantly. The supervisor with the bowler hat standing on a wooden plank approves of the work, and an interested family looks on in the background.

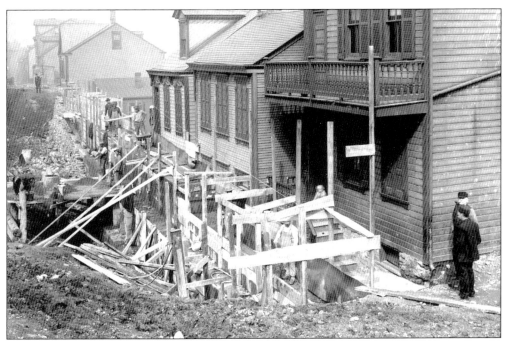

Construction continues at the corner of Mission Street and Greely Street on September 17, 1907. The workmen are digging and erecting wooden scaffolds. Again we see the porch where the woman stood before construction. The door is significantly below the plumb line strung over the scaffold.

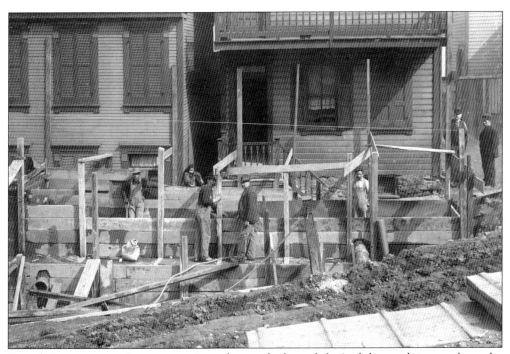

By early June, sewage pipes were put into place at the lower left. And the porch is now above the plumb line of the road and the front door well below it.

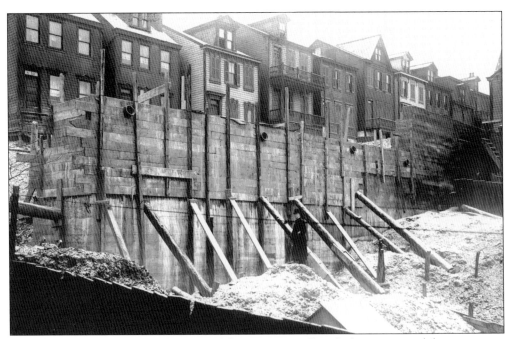

The superintendent inspects the front of the concrete wall with the sewage and drainage pipes above him. It is now December, and he wears a long coat to protect him from the cold.

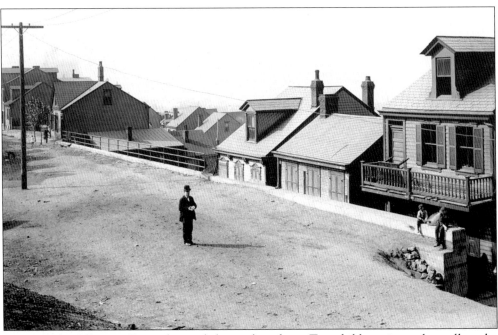

It is now the following September and the work is done. Two children sit on the wall at the corner of Mission and Greely Streets. The supervisor proudly inspects the completed work. The porch seen when work was begun can still be seen, but the first floor entry is below the wall and the porch is now at street level. The houses are still there today.

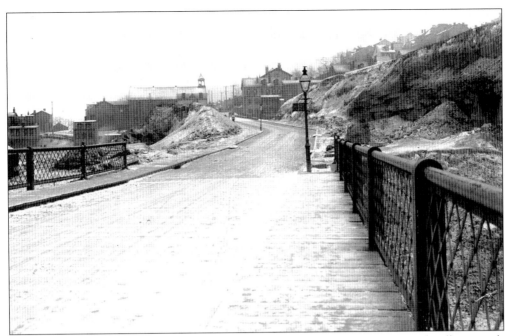

The Mission Street Bridge in December 1909 was originally a wooden bridge and walkway, with gas lights and a railing that is still there today. The bridge cost the city $34,000. The bridge spans the site of the former St. Clair Incline.

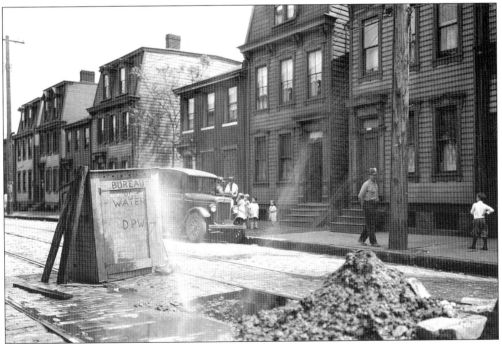

A 4-inch water main breaks in the 1800 block of Mary Street on May 14, 1930, as children watch from behind the truck and a passerby continues to go about his business. Three-story Second Italianate mansard roofs can be seen along the street.

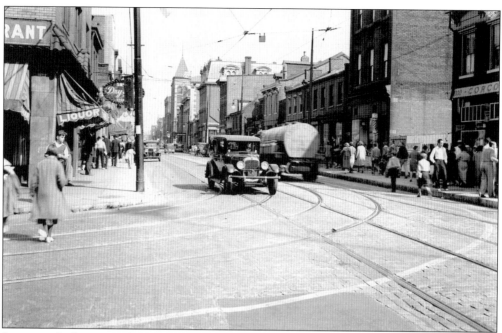

In a view looking east from Tenth and Carson Streets in September 1935, the Metropolitan restaurant can be seen in the left foreground.

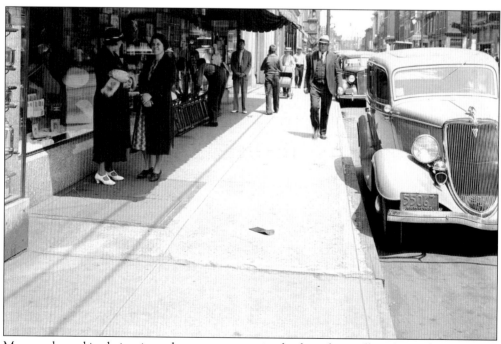

Men are dressed in their suits and women are wearing heels as they walk in front of 1311 Carson Street in June 1935.

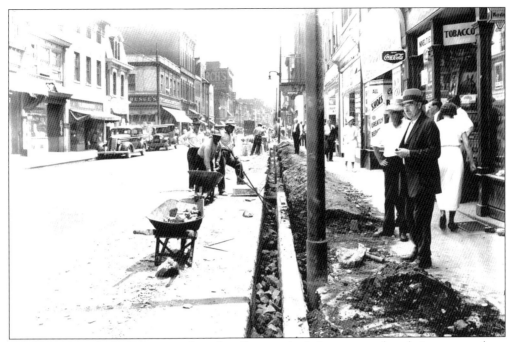

In July 1935, workmen are paving the sidewalk as a suited observer watches their progress along the 1400 block of Carson Street.

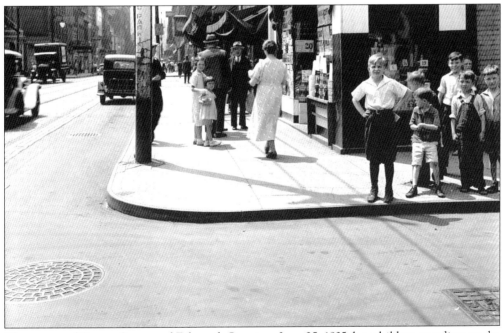

The corner of Carson Street and Fifteenth Street on June 25, 1935, has children standing on the corner, with the oldest boy's hands on his hips looking at the photographer.

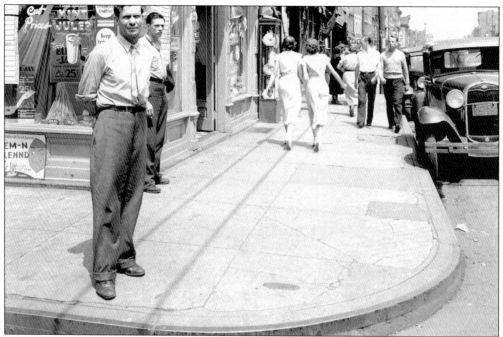

Two men stand in front of Wyant's Drug Store on the corner of Fifteenth and Carson Streets in the summer of 1935.

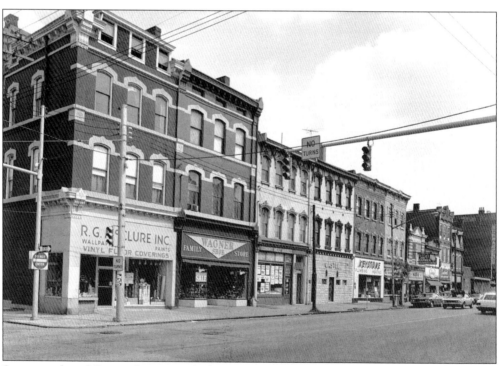

Seventeenth and Carson Street was the home of McClure Wallpaper Store, Wagner Shoe Store, Economy Meat Market, Castle Bar, and Keystone Plumbing Company.

Built in 1893, 1739 Carson Street was originally the home of the Mary Mohrhoff Millinery Hat Shop. Part of the building was rented to the Farmers and Mechanics Bank. In the 1930s, it became Lublin's Furniture Store as seen here in 1937. Today, it is the UPS Store.

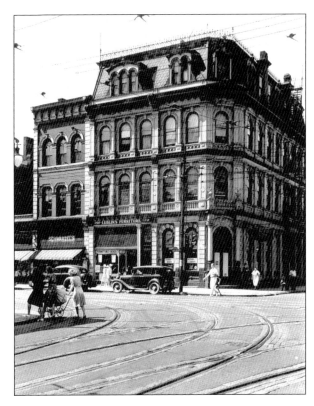

Henry Sorg constructed 1805 Carson Street in 1874 after he emigrated from Germany at the age of 18, in 1852. Today, this beautiful Victorian Second Italianate building is known as Fatheads. Henry boarded the *Yankee Blade*, crossed the Atlantic in 39 days, landed at Ellis Island, and immediately departed for the South Side by train, steamboat, and canal boat.

Here we see a view of 1930 Carson Street looking east on a spring day in April, as a young girl is window shopping. Solof's Furniture is on the far corner. Concrete has begun to replace the crisscrossed brick sidewalks, and automobiles have replaced the horse-drawn buggies.

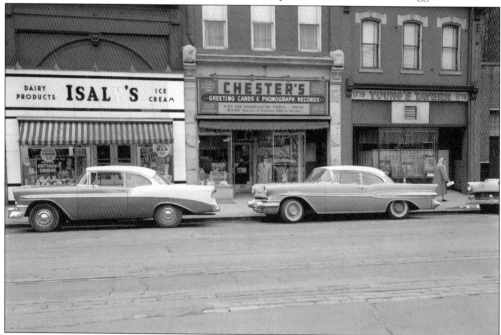

Isaly's Dairy, at 1715 Carson Street in 1957, was near Chester's Greeting Cards and Young's Tavern. Isaly's was founded in 1931 and was famous for Klondikes and chipped ham. The building was built in 1882. This was also the home of the Royal Theater and the Novelty Theater from 1916 to 1922. Today, Isaly's is Tom's Diner, which is open 24 hours a day.

70

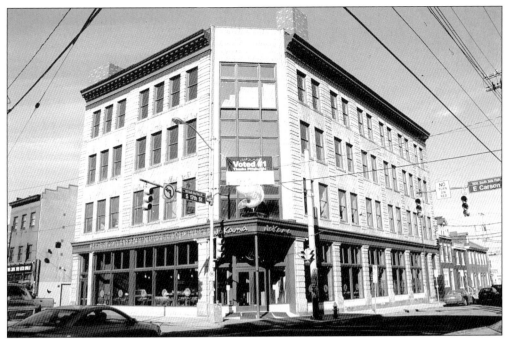

Present-day Nakama Japanese Steak House, at 1611 East Carson Street, was built around 1900 in the American Renaissance style. The angled front was redone in 1922. On May 6, 2005, the Pittsburgh City Historic Review Commission gave Nakama's a preservation award for their excellent work in renovation. Nakama means friendship in Japanese.

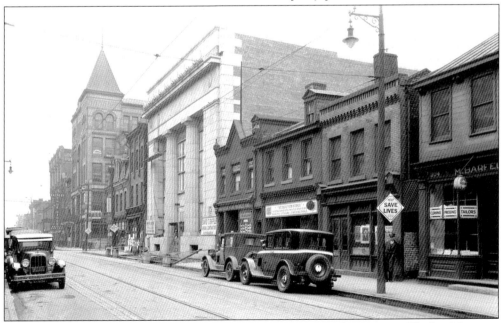

In 1871, a group of iron and glass producers wanted a place to put their savings. The bank became known as the Iron and Glass Savings Bank of Birmingham. The bank started with $100,000 as its capital. It opened for business at 1203 Carson Street and later moved to its present site at 1114 Carson Street. The first dividend was 5¢.

The German Savings and Deposit at Carson and Fourteenth Streets was founded on March 19, 1817. The name was changed to the Fourteenth Street Bank in 1918. By 1975, it had become Mellon Bank.

This building at 2302 Carson Street was built in 1880 of Victorian Italianate design with deep brackets on the roof line and varying shapes of the windows. In 1916, it was the Empire Laundry Company, in the 1980s it was Tambellini's Restaurant, and at present this historic building is a popular and appropriately named restaurant called The Bridge.

Six

THE STORES, SALOONS, AND HOTELS

Over a century ago, Carson Street was the Washington Pike, the main road between Pittsburgh and Washington, Pennsylvania, where it connected the great National Pike by a branch road. It was the life blood of the community. By 1884, it had 11 shoemakers, 15 merchants, 4 taverns, 3 breweries, 1 chair factory, 2 cabinet makers, 1 saddler, 8 carpenters, 2 tailors, 1 plasterer, 2 doctors, 1 barber, 7 coal merchants, and 2 bakers. It was a crowded place where nearly six people lived in each house. It was a rough town with cock-fights, dog-fights, prostitution, heavy drinking, horse racing in the streets, and billiards. The new century brought electricity, gas for street lights, electric trolley cars, and incline planes. It was the start of the Gilded Age. This was the place where the people who built the iron and steel for America spent their time and their money in the shops and saloons, which supported the community. In 1996, East Carson Street was recognized as a "Great American Main Street" by the National Main Street Center.

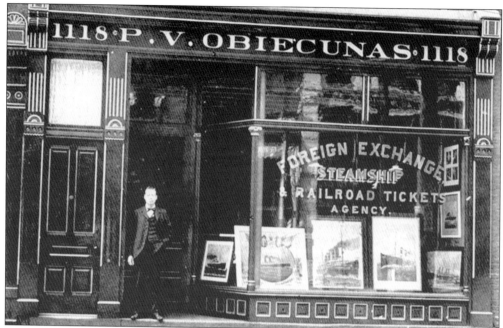

In 1835, the P. V. Obiecunas Store at 1118 Carson Street was also a railroad ticket agency. There was an increased demand for stores during this time to accommodate the rapid growth of the town and the community. In 1835, the Birmingham had a total population of 600 people, who occupied over 100 houses and grew to 3,741 people by 1850.

This is an unidentified building, with flags, rounded portraits of important people, and what seems to be a prominent place in the community.

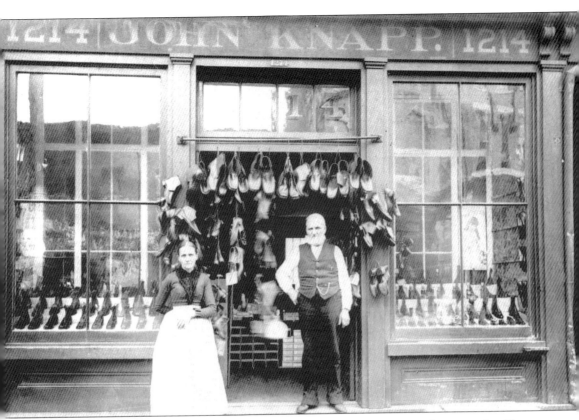

The John Knapp Shoe Store, at 1214 Carson Street in 1886, made custom shoes to order. Here, John Knapp and his wife are in front of their store.

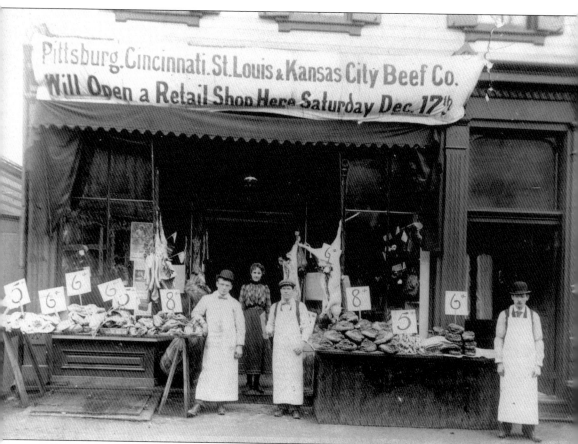

Shown here is a butcher and meat shop at the corner of Twelfth and Carson Streets when Pittsburgh was still Pittsburg (with no "h"). The meats are displayed in the open air. The prices are in cents.

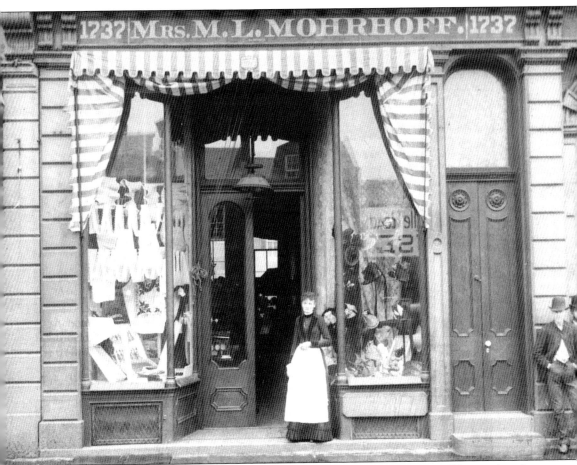

Seen here is Mary Mohrhoff in front of her millinery shop at 1737 Carson Street. Women played a part in the commercial district and were business owners as well. The store is still there today.

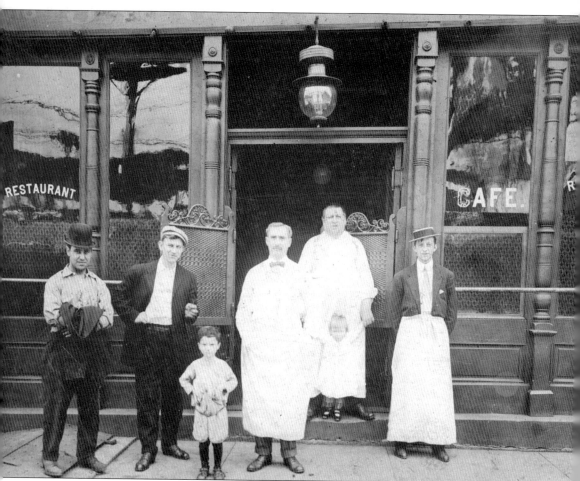

Jacob Scherrer owned and operated this saloon from about 1900 to 1914. The initial address was 2600 East Carson Street. Later, it became 2618 East Carson Street. Many of the customers were workers at the South Side works of Jones and Laughlin Steel Corporation. Scherrer is standing in the doorway. Before he owned his own saloon, Scherrer worked as a bartender at other saloons.

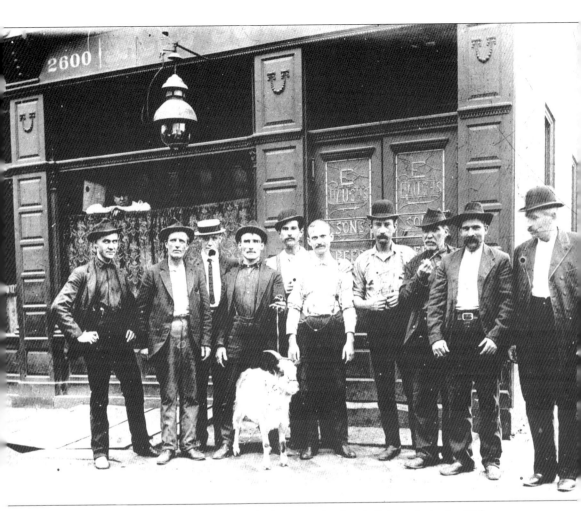

It is said there were over 90 neighborhood saloons in the South Side early in the 20th century. The men would stop on their way home at the end of their shift and be greeted by boilermakers, or a shot of whiskey and a beer, lined up on the bar. Here, friends gather in front of Jacob Scherrer's Saloon and Restaurant at 2600 Carson Street. In the front is Billy the Goat. Many families in the South Side kept goats for milk and meat.

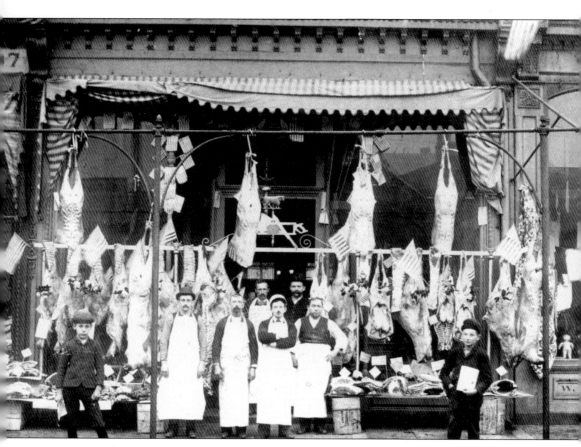

George Eisele owned several butcher and meat shops in the South Side. Seen here is his shop at 4307 Carson Street around 1905. He has pulled back his awning and brought out his best meat for the public to see. The display of American flags suggests a patriotic day, but the children are dressed too warmly for the Fourth of July. Slaughtered pigs, goats, sheep, and cattle are hanging from meat hooks.

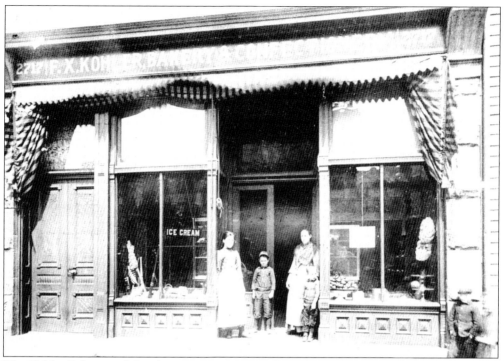

The Kohler Bakery and Confectionary at 2717 Sarah Street was a popular place for treats and special occasions.

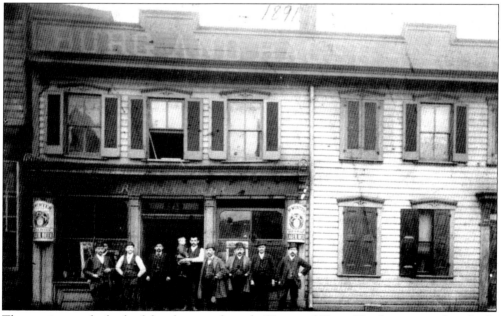

The caption on the back of the photograph reads, "Burg and Hager Hotel, now site of southside office. Office is built around old hotel and saloon. 1891. The double house at 2719-21 Carson Street, was owned by John Lutz before Burg and Hagar. J&L bought the building in 1899. Jacob Burg then had to build the house across the street. Now Yarski's Tavern. Man to left of doorway, Peter Wagner, Henry Wagner, Jacob Burg with son Jacob."

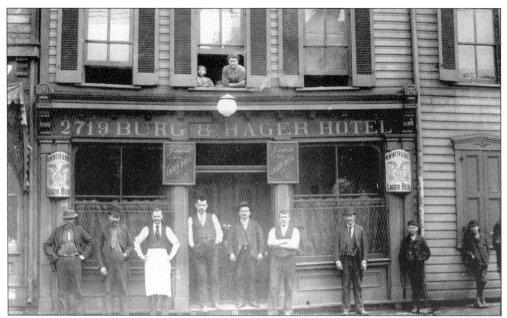

It was said that the town motto was, "a compound of worship on Sunday and whiskey on Monday, thus blending the spirits." The caption on the back of the photograph reads, "Burg and Hager Hotel and saloon, 1896. S. S. Office built around old building. Left to right 1-Paul Casper-No. 8 Mill 2-3-Peter Wagner 4 Jacob Burg 5- Henry Hagar (Little Henry) 6-Coonie Landshuter 7-8-9-10."

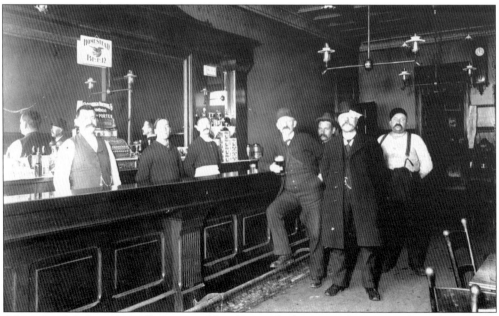

After a hard shift in the mill, men would gather in the bar, put a foot up on the rail, and have a shot of whiskey and beer to quench their throats. The caption on the back of the photograph reads, "Inside Burg Hotel—now Yarski's—about 1907. 2724 Carson Street Behind counter 1-Jacob Burg 2-Frank Rigot, (Burg's nephew) 3-Mike Snyder Heads, Left to right in front 1-Jacob Gaub 2-Grill (?) 3-Pfisterer 4-Pete Stief (rougher #8 mill)."

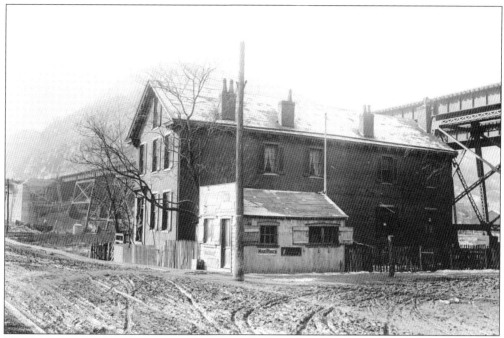

The James Hayes Mansion was located at 4600 Carson Street. Here we see the mansion and store in the early 1900s. By then, Charles Butterweck owned the house. The road to the right of the building is Beck's Run Road.

Hanna (1859–1926) and George Henry Butterweck (1857–1918) are standing on the porch of the James Hays Mansion, 4600 Carson Street.

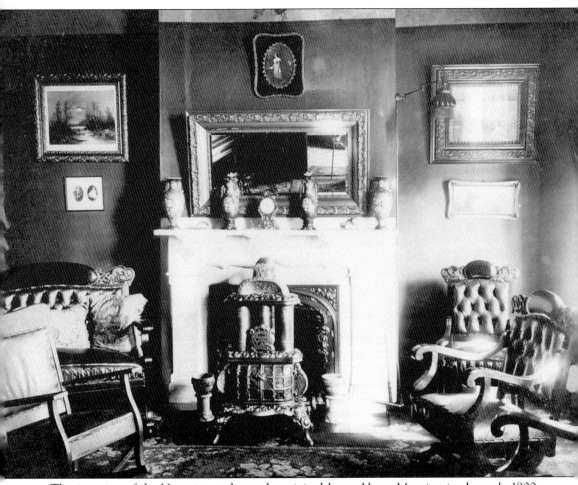

This is a view of the Victorian parlor at the original James Hayes Mansion in the early 1900s, when the Butterwecks owned the home. The chairs were stuffed with horse hairs.

Seven

THE BRIDGES CROSSING

THE MONONGAHELA

Pittsburgh is known as the "City of Bridges," and in Pittsburgh there is no place where there are more bridges than the South Side. They reach out like mighty fingers to connect the South Side to downtown. In fact, there would be no South Side without bridges. Before the bridge, the only way to cross the river was by ferry. Before the construction of the dams around 1900, the rivers were shallow enough to walk across in the summer when the water was low. There were lots of islands and sandbars in the middle of the Monongahela, where grain was grown.

The history of the bridges is a fascinating chronicle of the emergence of the South Side as an industrial center. The following is a brief outline of the bridges and their development from the point (west) where the Allegheny and Monongahela merge, up the Monongahela River to the south and east. They are in order from west to east, the Monongahela Bridge (later to become the Smithfield Street Bridge), the Wabash Bridge, the Panhandle Bridge, the Liberty Bridge, the Tenth Street Bridge, the Brady Street Bridge (later to become the Twenty-second Street Bridge), and the Hot Metal Bridge.

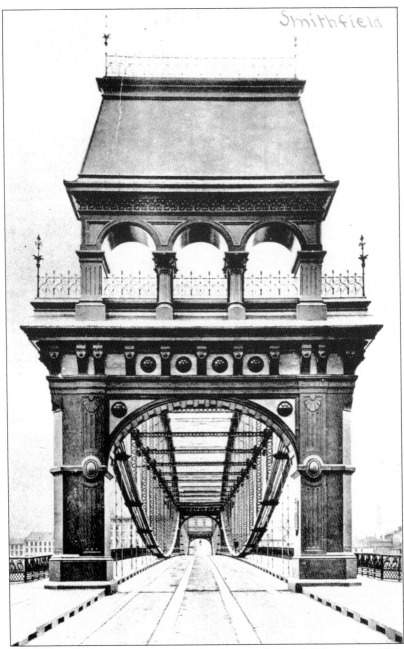

The first bridge in Pittsburgh was a covered bridge designed by Lewis Wernwag in 1818. It crossed 1,200 feet of river at Smithfield Street. It was originally called the Monongahela Bridge but later was renamed the Smithfield Street Bridge. Before the bridge was built, all traffic passed from one side of the river to the other by ferry. Joseph H. Thompson designed the bridge. The price was $110,000. It was a toll bridge and was constructed of wood and iron. It burned in 10 minutes in the great Pittsburgh fire of 1845, which destroyed over 1,200 buildings in the downtown area. John Augustus Roebling, who later designed the Brooklyn Bridge, rebuilt the bridge in 1846 as a suspension bridge. It was finally rebuilt in 1883 as a lenticular bridge. This is the south portal of the Smithfield Street Bridge in 1894.

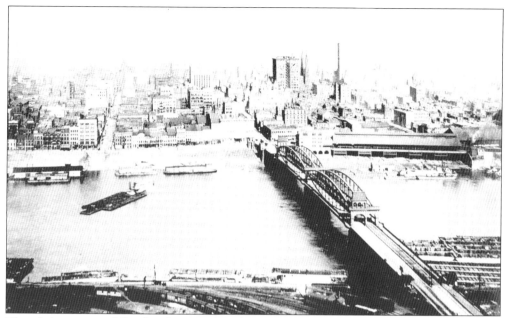

This skyline view of Pittsburgh was taken from Mount Washington in the 1890s, with the Smithfield Street Bridge connecting town to the South Side. Riverboat steamboats head toward the Monongahela wharf on the north side of the river.

This is a view of workmen building the south sidewalk to the Smithfield Street Bridge in 1907. In the background can be seen Dad's Inn, Boleyn's Hotel Birmingham, and other shops. The Smithfield Passenger Station was located at the end of this row of buildings.

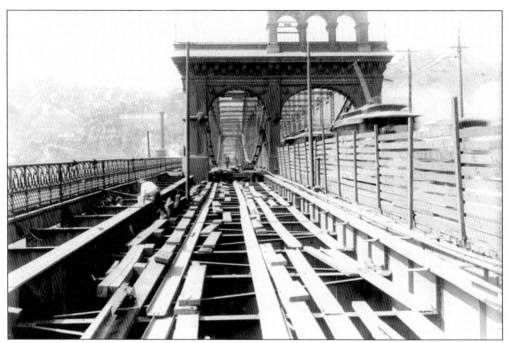

In 1846, it cost 2¢ to walk across the bridge, a horse and rider 6¢, sheep 2¢, and a head of cattle 3¢. In 1865, the bridge was lit by gas, and the 2¢ toll was reduced to 1¢ per person. This is a view of the Smithfield Street Bridge when it was widened in July 1911.

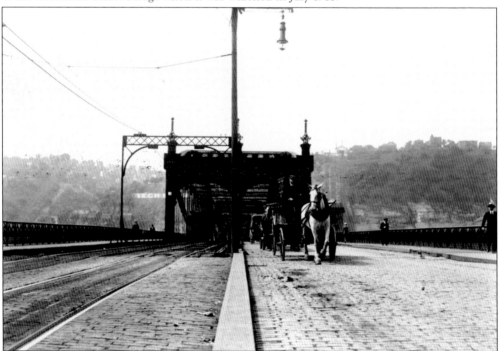

A horse and buggy travel from the South Side across the Smithfield Street Bridge to town in July 1917. The two lenticular main spans are 360 feet each and are the largest in the United States. The length of the bridge is 1,184 feet, with a deck height of 42.5 feet above the river.

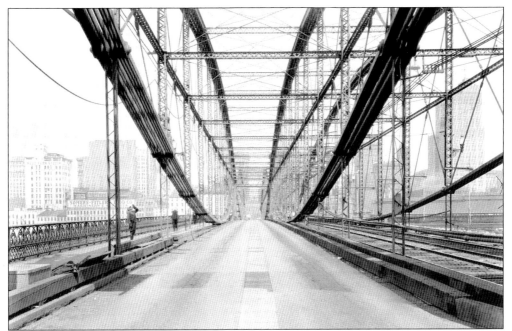

Roebling's 1846 bridge was demolished in 1883 and redesigned as a lenticular bridge by Gustav Lindenthal in 1884. In 1915, Stanley Roush designed the present portals. In 1934, the wrought-iron floor was replaced with aluminum. In 1994, the aluminum frame was replaced by steel, re-lit, and painted as it appeared in 1915.

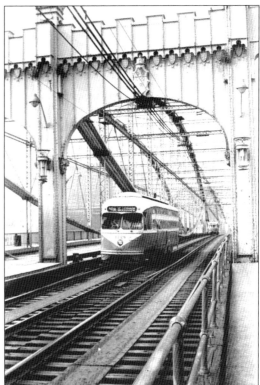

This is a view of streetcar 1728 of the 42/38 Mount Lebanon/Beechview route, on the Smithfield Street Bridge in 1967. The St. Louis Car Company built the electric trolley line in 1948.

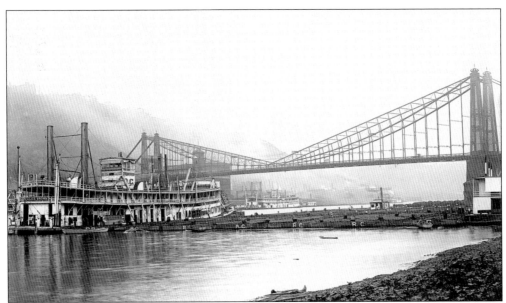

The steamers *Alice Brown* and *Raymond Horner* can be seen approaching the Wabash Bridge in 1912. The cantilever bridge was built in 1904 by George T. Barnsley with a total length of 1,504 feet, with a deck height of 46 feet above the river. The Wabash-Pittsburg Terminal Railroad was the idea of George Jay Gould. In 1948, while the bridge was being torn down, a worker got his leg stuck between the girders and had to have his leg amputated to free himself. The piers are still standing near the Gateway Clipper landing and Stanwix Street.

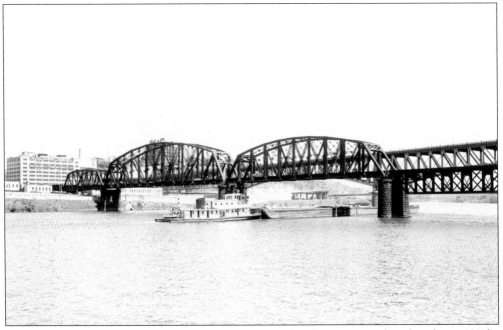

The Panhandle Bridge was built in 1861. It was modified in 1881 and replaced in 1903 by the American Bridge Company. It has seven trusses spanning the river and was named for the panhandle of West Virginia, where the railroad entered western Pennsylvania. Since 1989, it has been a part of the "T" light rail system operated by the Port Authority of Pittsburgh.

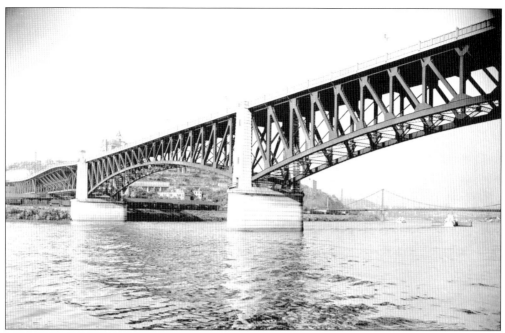

The Liberty Bridge was built in 1928. It was designed by George S. Richardson. It has 420-foot main spans, with a total length of 2,663 feet and a deck 44 feet above the river, connecting downtown Pittsburgh to the Liberty Tunnels and then to the South Hills.

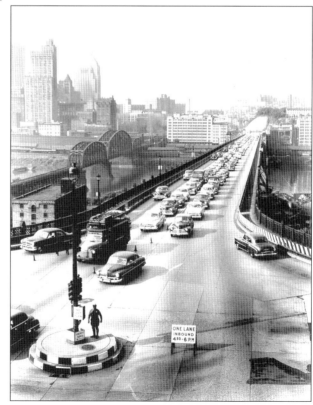

Policemen direct traffic from an island in the middle tunnel entrance during rush hour in 1951. At the time, the Liberty Bridge tunnels were the largest vehicular tubes in the world. They are over a mile in length, with a separate tube for each direction.

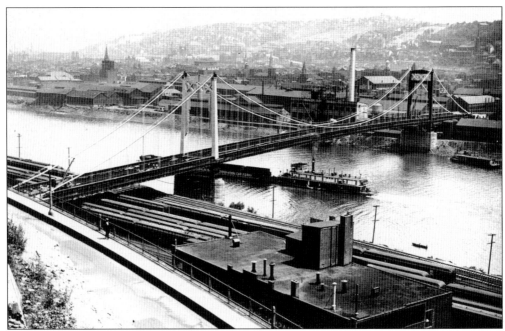

The Tenth Street Bridge was originally built as a covered bridge and opened to the public in 1861. In 1904, it was replaced by a steel truss bridge, and in 1933, it was replaced by a steel suspension bridge. It is the longest span on the Monongahela River. Look for dinosaurs or ducks on the top of the South Side span that have been painted by a phantom painter.

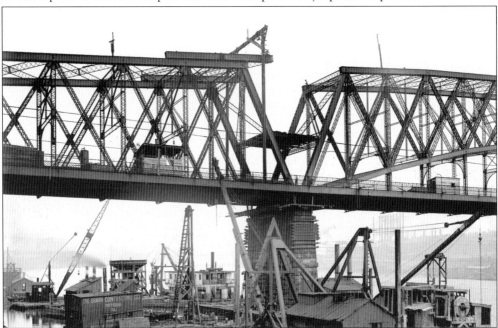

Seen here are the Brady Street Bridge piers and falsework under construction in August 1909. The original bridge was an iron and steel truss bridge and was the first toll-free bridge in Pittsburgh. It connected the north shore with the south shore of the Monongahela River. The bridge emptied out onto Carson Street at Twenty-second Street.

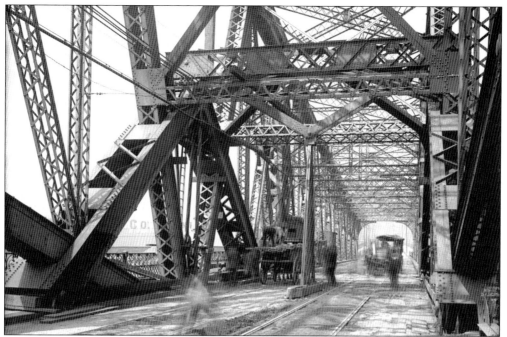

This is a view of the Brady Street Bridge looking toward the South Side and Carson Street in September 1910. One side was for the horse and buggy and the other side for horse-drawn and electric trolleys.

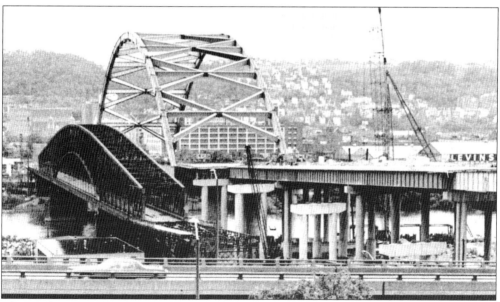

The Brady Street Bridge was replaced by the Birmingham Bridge, using explosives on May 30, 1978. The explosion did not work as planned, and the superstructure blocked the Monongahela navigational channel for 12 days. The $23 million Birmingham Bridge was built by Buchart Horn Incorporated. It opened to traffic on September 2, 1977. The new bridge was originally designed to connect to the Mon Valley Expressway, but the expressway was never completed. That is why it ends in a "T" at both ends of the bridge and there are "ramps to nowhere."

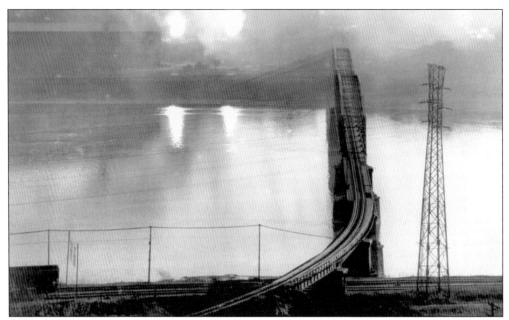

Shown here is a view from the north side of the Monongahela, looking towards the Hot Metal Bridge as flames shoot out of a pair of Bessemer's converters in 1953. Once the iron was purified in the Eliza blast furnaces, it was carried across the Hot Metal Bridge by the Monongahela Connecting Line, to be made into steel in the open hearths and Bessemer converters on the South Side.

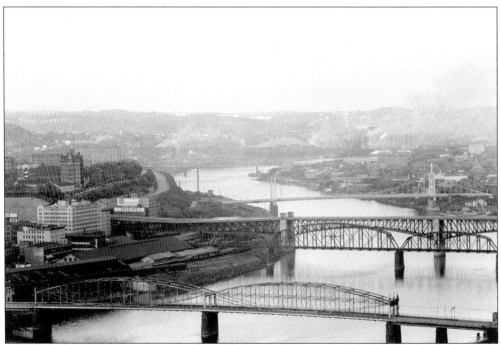

Clyde Hare took this picture of the bridges across the Monongahela in 1951. In the foreground the Smithfield Street Bridge can be seen, behind it are the Panhandle Bridge, the Liberty Bridge, the Tenth Street Bridge, the Birmingham Bridge, and the Hot Metal Bridge.

Eight

THE SCHOOLS, HOSPITALS, AND LIBRARIES

Reading and writing were important to immigrant families and their children. Part of the new American culture was to be literate. There were many parochial schools set up by the parishes in the community to provide this education: St. Casmir's, St. Michael's, St. Peter's, St. Albert's, St. John the Baptist, St. Matthew's (built in 1916, now Waldorf School, 1822 Harcum Way), Holy Cross, and St. Josephat's, which was built in 1881 at 434 Ormsby Avenue. Today it is Bishop Leonard Catholic School, named after the first Pittsburgh born priest to be appointed bishop in 1969. Arlington Elementary School, 2500 Jonquil Way, was built in 1961. Phillip Elementary School, 800 Rectenwald Street, was built in 1955. It was named after Union leader Phillip Murray.

Another priority was physical health. St Joseph's Hospital, founded in 1902 by the Sisters of St. Joseph, was located at 2117 East Carson Street. The original six-story building, opened in 1904, was built on the site of an old homestead. It closed in 1977, and in 1982, the hospital was disbanded and was taken over by Carson Towers, an assisted-living home for older adults.

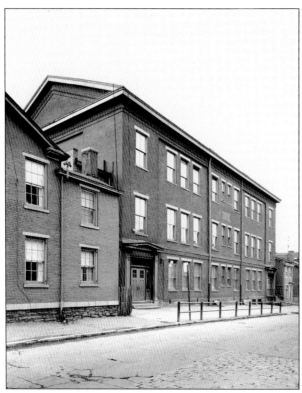

The Bedford School located at Tenth and Bingham Streets was originally known as Birmingham School but changed its name in 1873 when the school was annexed to the city of Pittsburgh. It was named after the founder of Birmingham, Dr. Nathaniel Bedford. The school was first opened in 1850, making it the largest and oldest school on the South Side.

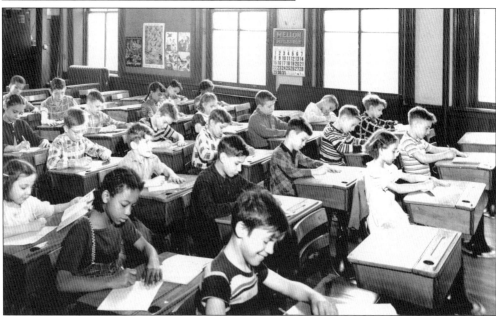

Wooden desks with holes for ink wells, calendars on the wall, and no air conditioning marked a Bedford School classroom in this 1950s photograph. It is the oldest surviving public school building in the city of Pittsburgh. Initial enrollment was 80 students. The girls went to class on one side and the boys on the other. It had no lights and was heated by open grates in each room.

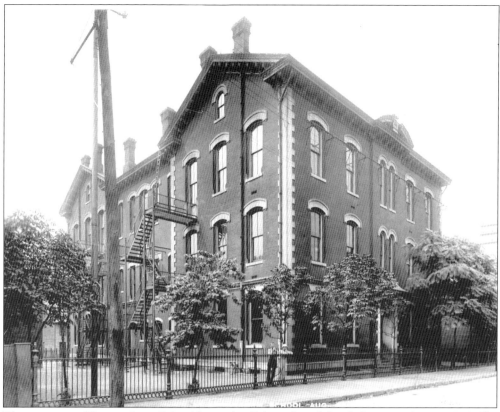

This is a view of Birmingham School located at Fifteenth and Sarah Street in August 1916. The school was opened in 1871. In 1895, it began the first kindergarten in Pittsburgh. The school was closed in 1943 and sold to the Catholic Diocese of Pittsburgh.

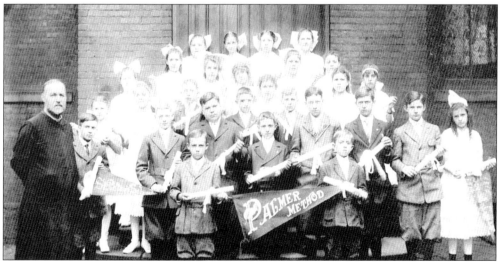

These students of St. Peter's Roman Catholic School in 1916 are holding their Palmer writing diplomas in their hands. The girls are dressed in white with big bows in their hair, and the boys are decked out in their finest suits. Writing was a valuable skill in 1916. The pedagogue stands in the front of the class.

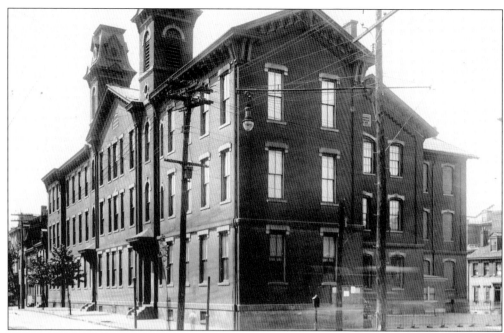

Here is an image of Humboldt School in 1890. Humboldt School was built in 1867 at 1901 Sarah Street. The original building had nine rooms. In 1881, nine more rooms were added and the building became a schoolhouse. The school was torn down in 1957, and a new school, Phillips Elementary School, named after the famed Union leader Phillip Murray, was built on the site.

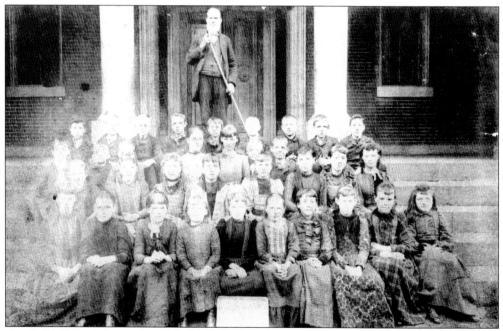

Humboldt School, located at 1919 Sarah Street, was first known as East Birmingham School. The name was changed in 1873 to honor Alexander von Humboldt, the German naturalist, scientist, and statesman.

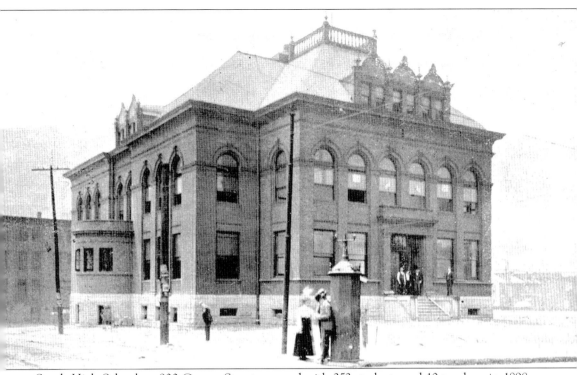

South High School, at 900 Carson Street, opened with 252 students and 10 teachers in 1898. By 1907, it had 371 students, and in 1924, it was enlarged with the addition of a west wing and became a junior and senior high. Edward Stotz was the architect. He designed the school in red terra-cotta and red brick in classic Renaissance style. The original cost was $72,243. The opening of the school was declared a holiday on the South Side. Businesses closed at noon, elementary schools were dismissed early, and there was a big parade led by the boy students on Carson Street. Speeches were made, interspersed with the singing of the girl students. In 1934 and 1937, South High won the state basketball championship. During World War II, South High was open day and night training men and women defense workers in machine, welding, and aircraft trades.

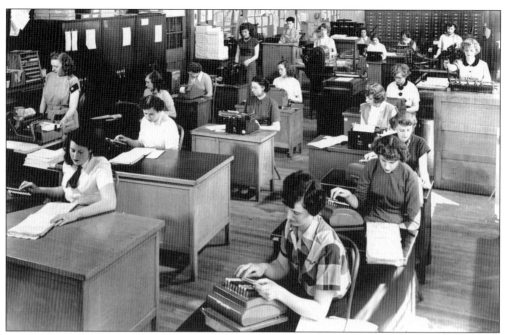

This is a South High typing class in 1951. When South High first opened, students were taught for two years and then transferred to Fifth Avenue High School. The new addition in 1924 was a flat-roofed structure, with a total of 38 classrooms, a swimming pool, a gymnasium, and a cafeteria. In 1940, the Vocational Building was opened for boys.

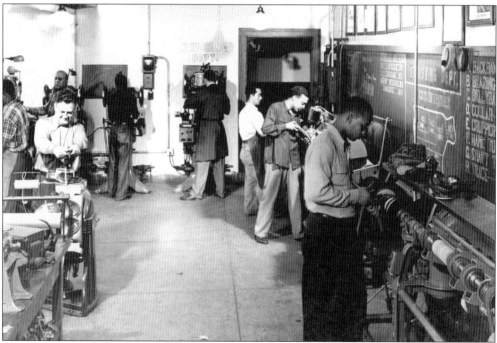

This is the South High School shoe repair shop in April 1951. In 1981, the school board decided to close South High, but public opinion and demand was so great, a public parade was held, and the school remained open as a vocational technical high school.

This photograph of the entrance to South Side High School in 1952 shows the dress style of the day: kilted skirts, Bobby socks, loafers, and shirts rolled up at the sleeves. There were no backpacks, hats, jeans, or tennis shoes. Beginning in September 1985, the school operated as a magnet school and was used for vocational and technical training for students from all over the city. It was renamed South Vocational-Technical School, or "South Vo-Tech." In 1997, and again in 2000, the board of education proposed closing South Vo-Tech, but no change was made. Finally, in 2004, South Vo-Tech closed. The school remains empty today.

South High Athletic Field on Carson Street was constructed in the early 1950s on the site of the Atterbury and Company "White House" milk factory. The new stadium was built in 1977, and it was the first city school to have an all-weather turf. In the early 1990s, the stadium became neutral ground for all the Pittsburgh Public Schools. In 1999, it was renamed George K. Cupples Stadium, in honor of a former director of athletics.

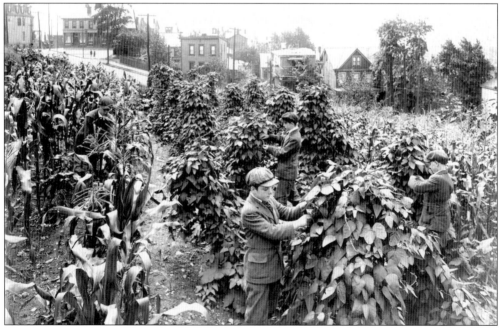

The Bane School Garden was located on the slopes at Fernleaf and Eccles Streets. Bane School was named in honor of James K. Banes, the supervising principle for Bane and Brashear Schools in the old St. Clair District. The school was built in 1895 and closed in 1959 when it was sold to the Catholic Diocese of Pittsburgh.

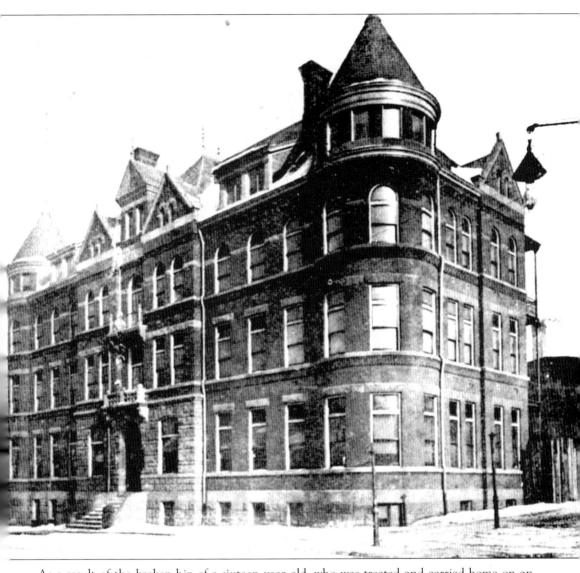

As a result of the broken hip of a sixteen year old, who was treated and carried home on an improvised stretcher, Dr. John Milton Duff organized the neighbors to consider the need of an accident hospital. They responded and started the first hospital of sorts in an old storefront warehouse on Twenty-second Street in 1889. The first hospital building was built in 1893 at a cost of $150,000, which was paid for entirely by contributions from the community. It had 30 beds. A new hospital was opened at Twentieth and Mary Streets in 1907, with a capacity of 70 beds. In 1913, a Nurses Residence was added, and in 1950, a nine-story East Wing was complete. The Oliver Annex was added due to the generosity of Amelia N. S. Oliver and her children in memory of James Brown Oliver. These buildings were demolished in the 1980s. In 1996, South Side Hospital became part of the UPMC (University of Pittsburgh Medical Center) Health System located at 2000 Mary Street, and today is UPMC South Side Hospital.

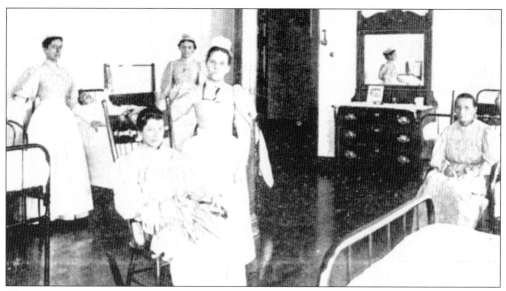

This is a view of the medical facilities of the South Side Hospital female ward.

Dr. Nathaniel Bedford was considered to be the first physician in Pittsburgh. It is said that one of his patients was Chief Red Pole, the Seneca chief, who did not recover from his illness and is buried in Trinity Cathedral Church Yard in downtown Pittsburgh, where Major Ormsby is buried as well.

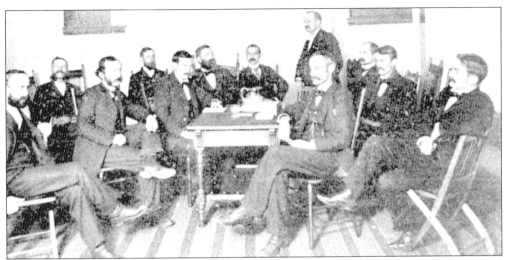

The South Side Hospital Medical and Surgical Staff in the late 1800s was largely the product of the advances in medicine during the Civil War. Dr. Peter Mowry was the first resident physician of Birmingham in 1811. By 1830, there were two doctors, and by 1857, five doctors in Birmingham. By the end of the century, there were fully developed medical staffs.

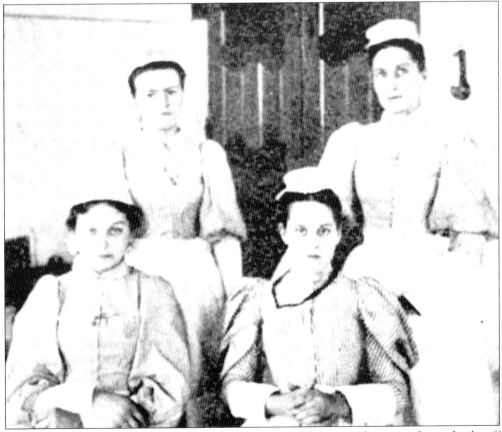

South Side Hospital nurses wore sterile white and were fully prepared to assist the medical staff and to take daily care of the patients.

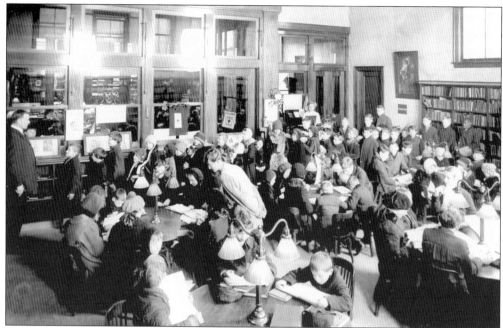

This interior scene of the Carnegie Library, shortly after its opening in 1909, shows children waiting in line to be the next one to read. An authority figure is ensuring that everything is done in an orderly way while the children wait for the opportunity to read a book. This room can be visited today. The library still has the original oak counters and a cabinet phone booth.

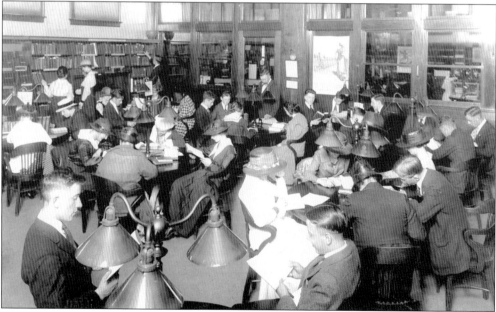

When the South Side branch of the Carnegie Library opened in 1909, 10,000 people visited in the first week and borrowed all of the books. Because the people of the South Side were immigrants, books were available in a variety of languages. In this view, each person is dressed in their Sunday best and every available seat is taken. The opportunity to read was a big deal in 1909.

Nine

SPECIAL PEOPLE AND SPECIAL PLACES

Special people have visited the South Side. Charles A. Lindbergh toured Carson Street on August 3, 1927, following his solo flight across the Atlantic Ocean, and Sen. John F. Kennedy visited Carson Street on October 10, 1960, when he was campaigning for president. But most importantly, the South Side was known then, and now, for its special people and its special places.

The mills along the Monongahela were the life blood of the community. They blended together as diverse a group of people as could be found in the new country. These were the people who hung their clothes out to dry in the hot filthy air on a clothesline with wooden clothespins; who were so proud of their dwelling places that they scrubbed the front steps every day; who lived in row houses, with no windows on the sides, that were two-stories high and one room wide, with little ventilation; who had no grass yards, playgrounds, or toys for the children; and who lived without fresh water most of their lives. Thomas Bell explained why he wrote his book *Out of This Furnace*, "*I wanted to make sure that the hardships my grandfather, my father, my mother and my brothers and sisters and other relatives lived through would never be forgotten.*"

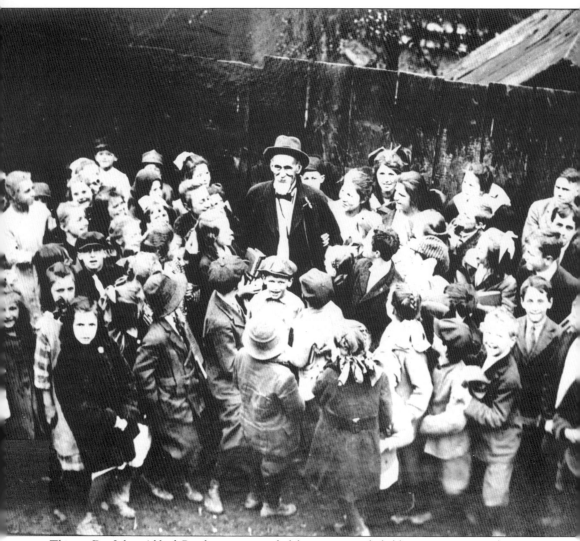

This is Dr. John Alfred Brashear surrounded by a group of children in 1900. Brashear was originally a millworker who was encouraged by his friend S. P. Langley and financially supported by William Thaw to become a famous scientist and lens maker. He formed the Brashear Company, which constructed the lens for the Allegheny Observatory in Riverview Park. He was self-taught and widely respected in the world of astronomy. "In his own South Side neighborhood, he was to all 'Uncle John,' a gentle, understanding man who loved children and was loved in return. His home at No. 19 Holt Street later became a community settlement house and his workshop there a small museum mainly as a result of the efforts of his close friends, who often gathered at his home to look through his telescope. He died in 1920." (Brashear Association.)

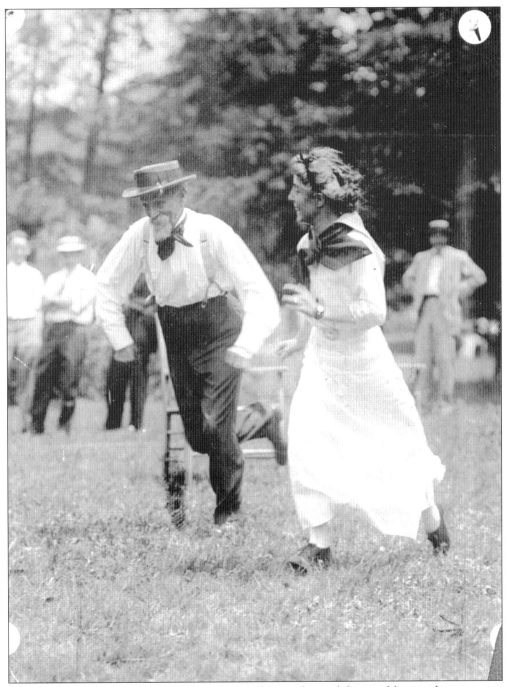

Dr. John Alfred Brashear is seen here at a picnic having fun with his neighbors and community. "In the world of science, Dr. John Alfred Brashear was known and honored for his precision instruments and lenses, which made possible many of the most important astronomical discoveries for this century. He was a moving spirit in the growth of the Allegheny Observatory." (Brashear Association.)

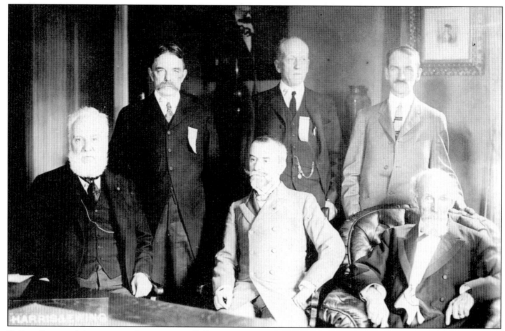

Scientists and inventors from around the country came to meet with Brashear, here he is with a gathering of scientists at Allegheny Observatory in May 1913. The visitors include, from left to right, the following: (first row) Dr. Alexander Graham Bell, Mr. Jusserand, and John Brashear; (second row) James Allen, Dr. Charles Walcott, and Glenn Curtis.

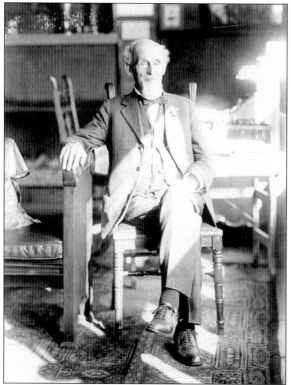

In his time, Dr. Brashear was one of the greatest scientists in the world, known for the construction of precision instruments, lenses, reflectors, and plates for spectroscopes.

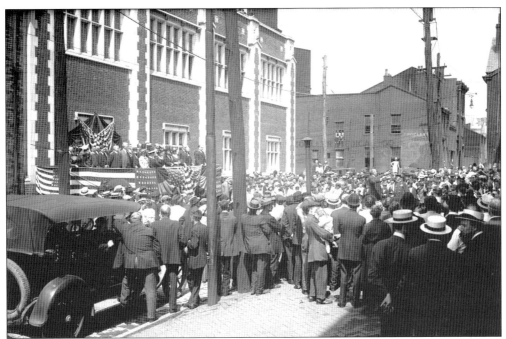

The Oliver Bath House in 1915, at Tenth Street and Bingham Street, was named after Henry B. Oliver of the Oliver Iron and Steel Company. At the time it was built, it was an opportunity for those who did not have bathrooms or bathtubs to get clean and enjoy the water.

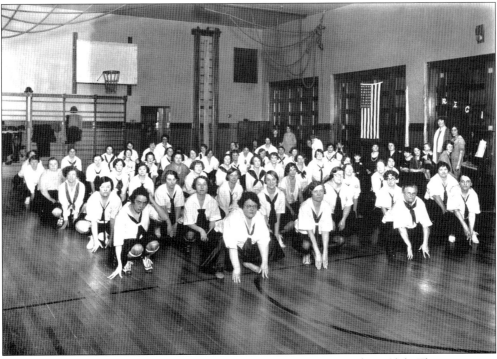

The Ormsby gym class for women in 1926 was called the Regina Mothers Club. The women are dressed in the athletic uniforms of the day and are ready for group exercise.

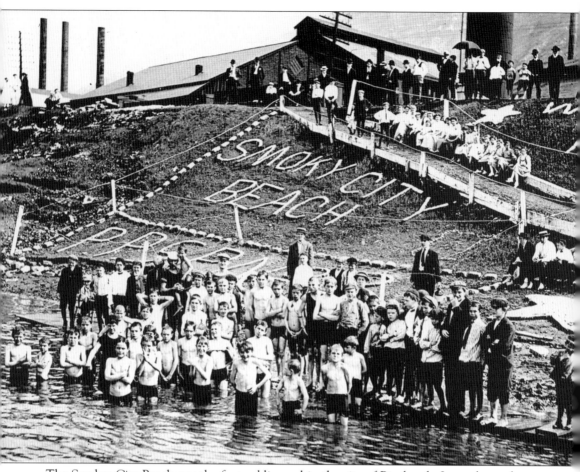

The Smokey City Beach was the first public pool in the city of Pittsburgh. It was located near Carson and First Streets on the banks of the Monongahela River in back of Painter Mill on the South Side. This photograph, taken in 1908, shows a group of happy boys already in the water, while the girls wait their turn as they sit on the ramp.

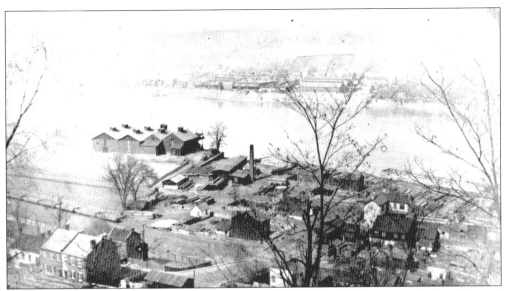

This is a view of the icehouses on the Monongahela in 1885, which were stocked with ice cut from the frozen river or shipped from Chautauqua Lake in southwestern New York.

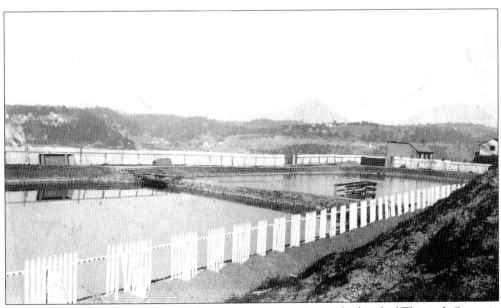

The Monongahela Water Company built a pumping station at the head of Thirtieth Street in 1865. Here is the reservoir and pumping station being cleaned in 1884 due to the scarlet fever epidemic. The piles of dirt that were taken out can be seen. The South Side did not have filtered water until February 4, 1909.

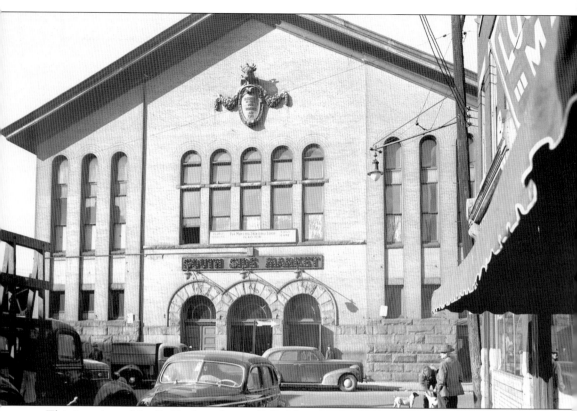

This is a view of the Bedford market in 1943. This was the fifth market to be built on the site. The land on Twelfth Street, originally known as Diamond Square, was given by Dr. Nathaniel Bedford to build the first market in 1816. It was destroyed by fire. Charles Bickel designed a new market in 1893, but a fire destroyed the building in 1915, and a new building was built in its place. Bickel's walls survived, but the four peaked towers were destroyed. The bull's head on the front of the building is the symbol for a market house. The market opened at 5:00 a.m. with the ringing of a bell by the clerk of the market. Farmers set up stalls outside to sell cuts of cheese from a wheel, fresh fruit, vegetables, eggs, poultry, and three pounds of butter from a tub for 25¢. Inside, counters were packed with racks of slaughtered cattle and pigs hanging from meat hooks. All purchases were wrapped in heavy paper and tied with string and put into a shopping bag, which every woman carried. In 1829, an ordinance was passed with a fine of 75¢ for hogs running wild in the market. In 1978, the new market was dedicated as the South Side Recreation Center, which offers a variety of indoor programs for children, adults, and Senior Citizens.

McKinly Fort was built in 1863, at the top of the Twenty-second Street Incline, bordering Sterling Street, to protect Pittsburgh during the Civil War. Another fort was located on Arlington Avenue near St. Peter's Cemetery. Attorney William C. McClure recalled, "Indeed I remember well both of the forts. They were thrown up during Morgan's raid. He had a bad reputation and everyone was afraid of him. They thought he would come up the Monongahela River from West Virginia, which would have been a logical procedure if he could have done it. So they put up the forts in the defense of this locality."

The old fort, built of mud and dirt was a big circle, 90-feet across. Inside the breast works there was a ditch and a mound, four- to five-feet high with hollowed-out places for cannons. Eventually, the fort became a part of Arlington Playground until a baseball field was built on the site and the fort was torn down so the dirt could be used as fill for the field.

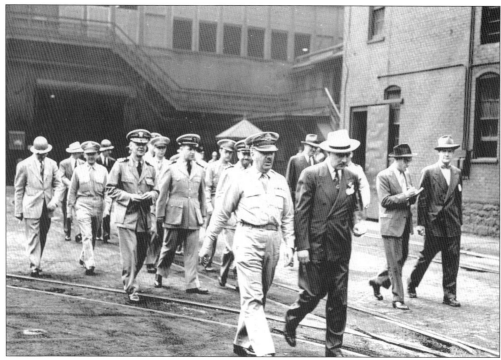

During World War II, the South Side played a critical part in the war effort. Here we see an army inspection of J&L in June 1943. Maj. James Hood Miller and L. T. Willison inspect the mill yard, which received the Army-Navy "E" Excellence award for its contribution to the war effort.

Maj. Gen. Levin H. Campbell Jr., Army ordinance chief, and Lt. Col. Robert C. Downie, middle, inspect the J&L plant in June 1943. A significant number of employees during World War II were women who worked on the production line.

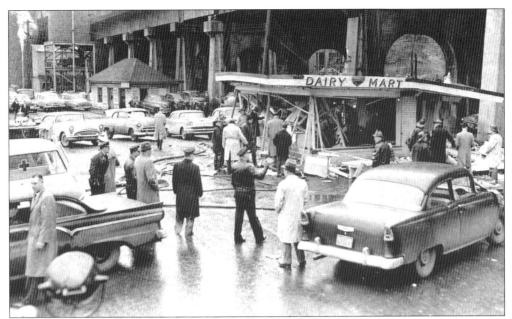

The Page Dairy Mart gas explosion on February 28, 1958, nearly leveled the building. Gas was leaking in the street and a cigar lit the fumes. This was one of the original drive-in ice-cream stands. The location was originally the James Hayes Mansion, which became Page Service Station in 1946; Charles Alexander Page was the owner.

This is a view of the Duquesne Brewery in 1910. The brewery was founded in 1899 and became the Duquesne Independent Brewery Company, the Duquesne Bottling Company, and the Silver Top Brewing Company. Its slogan was "Have a Duke, the Prince of Pilsners." The smokestack with the "W" is the Winter Brewery Company. The building in front is the Pittsburgh Brewing Company. The Duquesne Clock, which can be seen from across the river, was built in 1933.

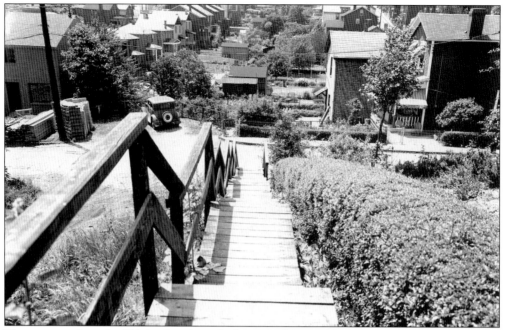

This is a view from the fifth landing from the bottom of the Walden Street Steps in the summer of 1950. The narrow streets of the neighborhood below can be clearly seen. The South Side slopes are known for their steps. For an understanding of the steps, see the South Side Steps Organization.

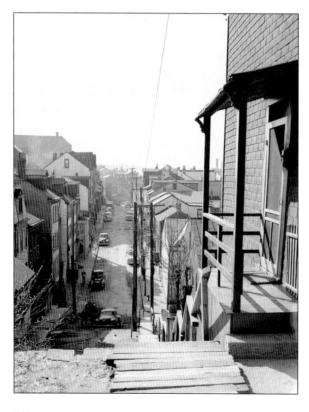

The Leticoe Street Steps below Mission Street in 1951 were steep and treacherous. Imagine what it must be like in winter to climb up and down these steps.

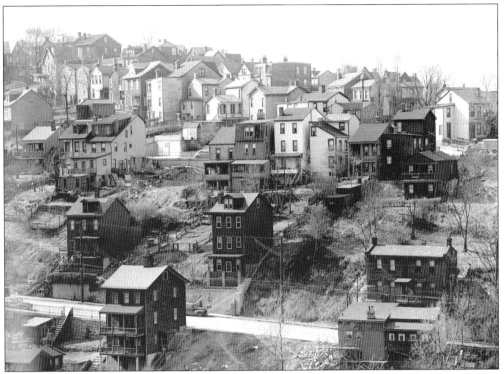

These houses on the slopes are located near Josephine and Twenty-seventh Street in 1951. The backyards of the houses on Sterling Street can been seen from Mission Street.

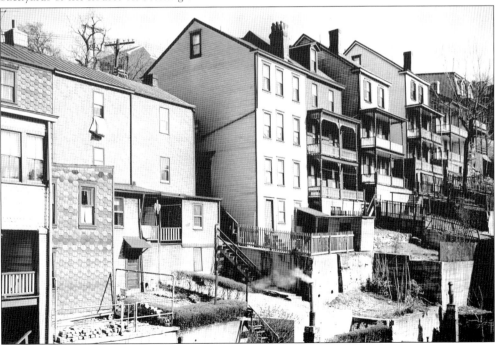

Looking at the backyards of the houses on Sterling Street from Mission Street in 1951, how ingenious people were with the little spaces in their backyards can easily be seen.

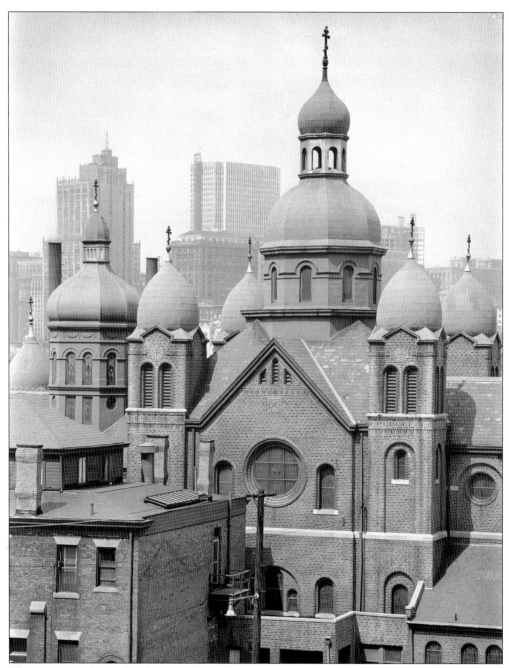

This is a view of St. John the Baptist Ukrainian Catholic Church at the corner of Seventh and Carson Streets in 1951. The church was built in 1895 by Gothard Wyss and was originally the Grace Evangelical Lutheran Church. The Byzantine domes were added in 1917.

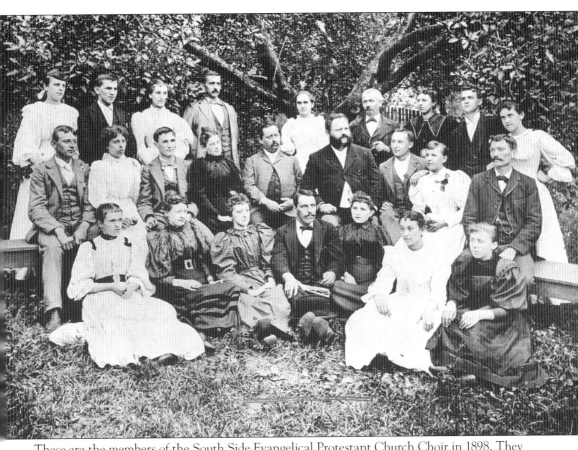

These are the members of the South Side Evangelical Protestant Church Choir in 1898. They are gathered at Jacob Bauer's Farm in Baldwin Township. Prof. Jacob Ott, with sideburns, was the director of the choir.

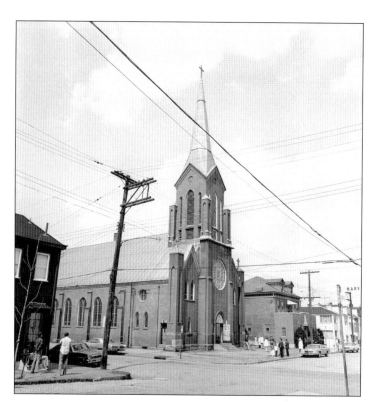

Shown here is St. Matthew's Roman Catholic Church at Nineteenth and Mary Streets. This is a photograph of the church in 1975.

This is a photograph of St. Mary's Russian Orthodox Church in 1975, located at Twentieth and Sarah Streets.

This is a view of St. Peter's Roman Catholic Church, which was built in 1871 on Twenty-eighth and Sarah Streets.

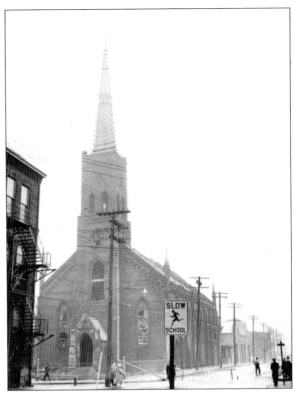

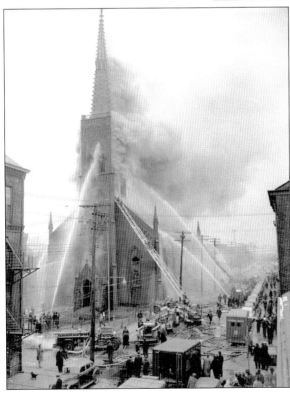

St. Peter Roman Catholic Church burned to the ground in a horrible fire in 1952.

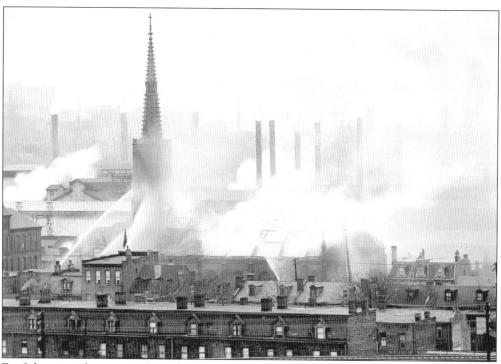

Firefighters are doing everything they can to save the building.

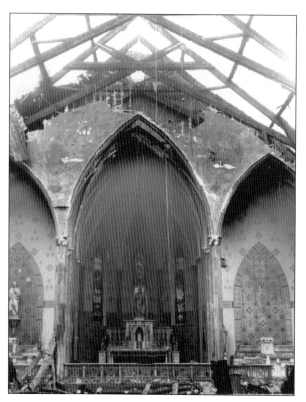

The aftermath of the fire, looking toward the front of the church, shows the total devastation of the building. The building was totally destroyed. Holy places that had served people for generations were gone.

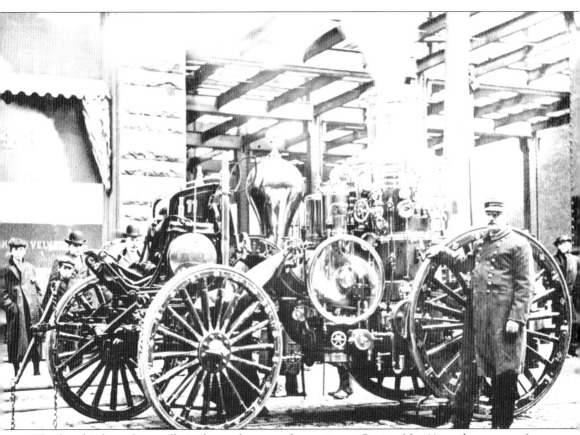

The fire chief stands proudly in front of a steam fire engine at Station No. 11 on the corner of Ninth and Bingham Streets. Known as the Mechanic Company, it was organized in 1866 and became a paid department of the City of Pittsburgh in 1870. The Hydraulic was the name of the first volunteer company on the South Side. The title was taken from the engine, which was still around in 1836. David Kay, an axe man for the company in 1889, recalls, "It was just a lot of rascals who ran with the machines, fought one another and the other companies, and squirted more water on the spectators for the fun of the thing than on the fire." Today, the professionalism of the fire companies protects the community.

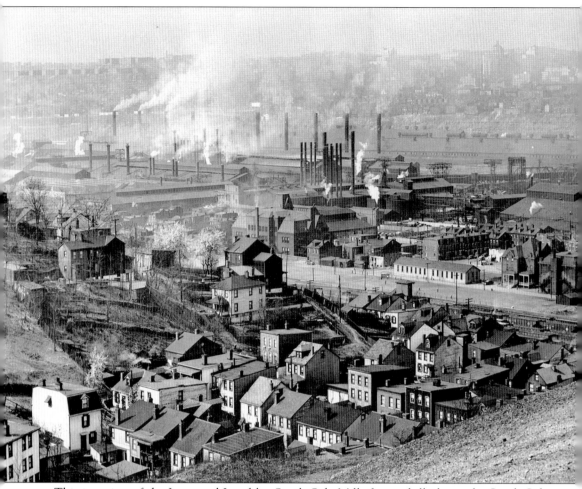

This is a view of the Jones and Laughlin South Side Mills from a hillside on the South Side taken in April 1948. J&L was a major defense plant during World War II. At the start of the war, J&L was the fourth largest producer of steel in the world, producing over 4.8 million tons of steel each year. It employed 45,000 workers. It has come a long way from the beautiful green village of 50 houses that it was in 1816. John Ormsby and Nathaniel Bedford had no idea what would become of their rural village. Today, Carson Street is filled with activity from the restaurants of Station Square to the stores of the South Side Works.

The Beneficial Building, at 1505 Carson Street, was built in 1881 as a Victorian Renaissance building with basket-handle arches over the windows and the top ornamented with corbelled brick. In 1916, the German Beneficial Union was located here. From the 1980s on, it was a Photo Hut. The restoration of the building is a remarkable example of how local groups are rebuilding the South Side. In 2004, the South Side Local Development Company and TREK Development Group purchased the vacant building with the help of a $250,000 loan from the Pittsburgh History and Landmarks Foundation.

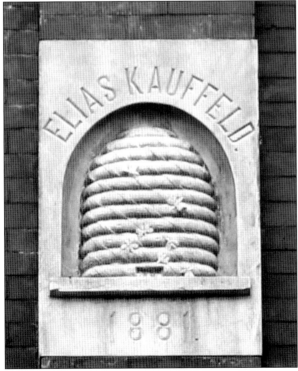

The carved date stone on the Beneficial Building is a symbol of a beehive surrounded by the name Elias Kauffield. The beehive symbol came from the German saying, "Hard work makes life sweet like honey."

Dressed in their spring hats, these women gather on freshly fallen snow in April 1902. Two of these shivering women are Nina Davis and Emma Thomas, although which ones we are not sure. At the time, it was considered immodest if a lady's shoes were exposed beneath her skirt. But women on the South Side found it difficult to keep their skirts clean, so they shortened them to only two inches above the ground—a fashion they called "rainy day" skirts. Following European fashion, they are wearing two-piece coats and skirts, which emphasized tight waists and broad hemlines. The woman on the far right is wearing a popular ostrich feather in her hat. The hair style was up-swept and was necessary to support the hats they wore. They have dropped their umbrella for the photograph.